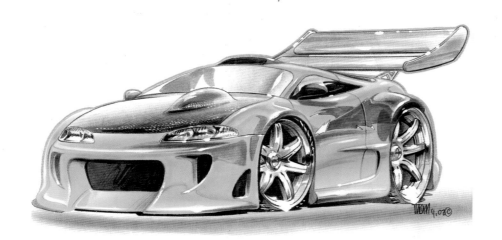

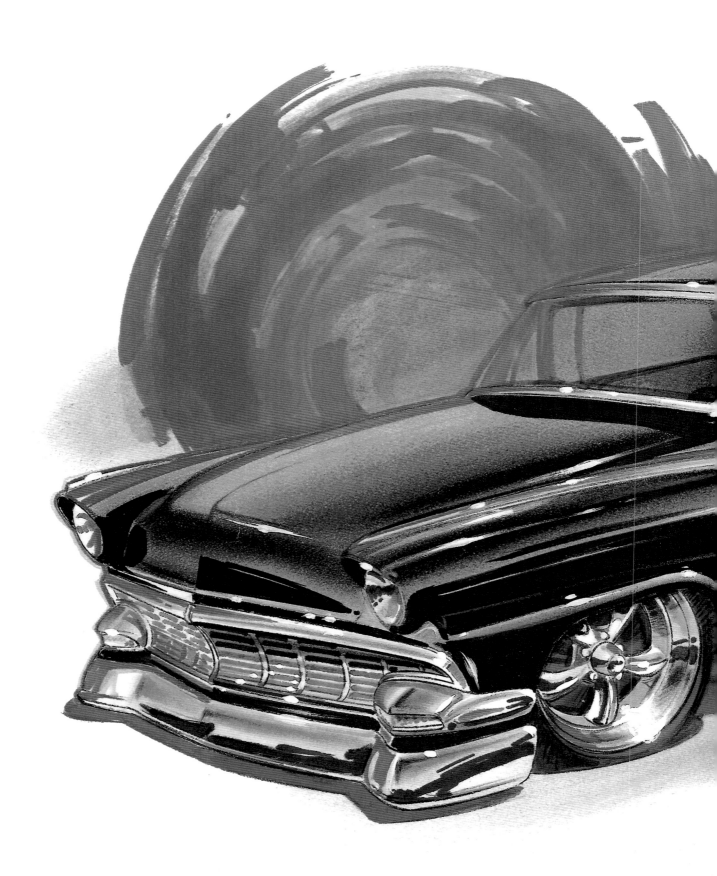

HOW TO
DRAW CARS
LIKE A PRO

2nd Edition

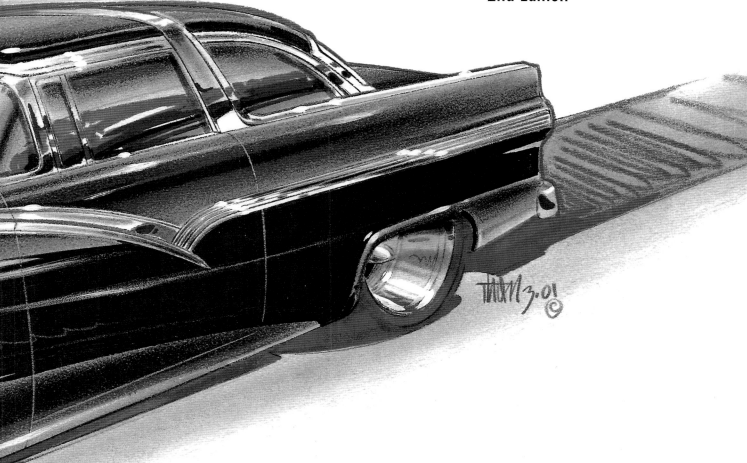

THOM TAYLOR

WITH LISA HALLETT

First published in 2006 by MBI Publishing Company and Motorbooks, an imprint of MBI Publishing Company, 400 1st Avenue North, Suite 300, Minneapolis, MN 55401 USA

Motorbooks titles are also available at discounts in bulk quantity for industrial or sales-promotional use. For details write to Special Sales Manager at MBI Publishing Company, 400 1st Avenue North, Suite 300, Minneapolis, MN 55401 USA.

To find out more about our books, join us online at www.motorbooks.com.

ISBN-13: 978-0-7603-2391-5

Editors: Zack Miller and Dennis Pernu
Designer: Kou Lor

Printed in China

On the frontispiece: Though the author doesn't do a lot of cartooning, he loves to practice it when the opportunity arises, as seen with the tuner car—or is that "tooner" car?

On the title page: To give his rendering some interesting reflections, the author throws around some color other than sky blue.

On the back cover: Whether your interests lie in doodling or designing your dream car, the principles outlined by Thom Taylor can put you on the road to some exciting illustrations.

About the authors

Thom Taylor is a four-time winner of the coveted America's Most Beautiful Roadster award and an inductee into the Hot Rod Hall of Fame. A graduate of Pasadena's Art Center College of Design, he has designed cars for builders like Boyd Coddington and Roy Brizio, and for celebrities Eric Clapton, Tim Allen, and Billy F Gibbons of ZZ Top. In addition to creating signature die-cast lines for Racing Champions, Revell, and Testors, Thom is the author of Motorbooks' *How to Draw Choppers Like a Pro*.

Lisa Hallett is a writer and editor based in Southern California. Her work has appeared in the *Los Angeles Times*, *Emmy*, and *Westways*.

Contents

Acknowledgments

More than 10 years after doing the first version of this book, and on the heels of *How To Draw Choppers Like a Pro*, Motorbooks talked me into doing a new version of the original *How To Draw Cars Like a Pro*, which you are now holding in your sweaty hands. I never thought I'd do this again, but in reviewing the first version I knew that all of my peers and I had advanced our art substantially since 1994, so I wanted to be able to show you what they and I have been up to these last 10-plus years applying to the test what we know about drawing cars.

The best thing about doing these books is visiting with all of the artists and/or designers I know personally who again have contributed to this book. It's great that, other than Mark Balfe, whom I have lost track of, every contributor to the first *Cars* book was so kind in coming back for a second shot. The only new face is Scott Robertson, who, besides being an exceptional designer and artist, happens to be the author of *How To Draw Cars The Hot Wheels Way*, another Motorbooks title. Scott's book can be considered a companion to this one, and is a great book for more details and techniques about computer art as it relates to cars.

So to all of you—thanks again for your great friendship and art.

Thanks also to my editor on both this and my *How To Draw Choppers*, Dennis Pernu. Poor Dennis has to put up with a lot of my rants and raves, and does a good job at it! Also thanks to Zack Miller and Tim Parker at Motorbooks. And thanks to my friend Tony Thacker who was the one to originally convince Motorbooks that a how-to about drawing cars might sell a few books.

Professions related to drawing and designing cars are in abundance, and companies that require this type of work are always looking for new talent. Besides employment from a single employer, there are many opportunities out there in the freelance world—in fact, I would say that most of the contributors to this book employ themselves either as freelance designers or illustrators, or own their own design studios. Real talent in the workplace is sparse, so if you really want to do this for a living and are willing to devote a lot of time and effort, there is a job waiting for you somewhere at this moment.

Sorry to say but you still see a lot of bad art out there, especially because cars have so many technical aspects to them such as ellipses, accurate perspective, and so on. This should encourage you to learn the techniques necessary to do great art because it's obvious when cars are drawn accurately, even in cartoon form, so it should be easy to bump off some of the lesser artists once better work comes along—your work for instance!

I ended the acknowledgements for the first *How To Draw Cars* by thanking my parents, Charles and Ann Taylor, not only to thank them but to convey to you parents that supporting and encouraging your budding artists as my parents did is important to help foster better self esteem, and to sustain the interest and enthusiasm for this type of pursuit. There are a lot of worse things out there than drawing cars occasionally in the margins of history lecture notes.

Finally, thanks again to my wife, Lisa, and children James and Chloe, who put up with those last two weeks of my angst before book deadline!

Now, let's draw some cars!

Introduction

A prominent Los Angeles surgeon I know once told me that the less the medical profession knows about something, the more they write about it. They could have filled a large room with books on polio before Jonas Salk discovered a cure; now, polio rates a paragraph in medical textbooks. I wonder if the opposite applies to drawing cars. I see poorly drawn cars in magazines, books, and ads all the time. Maybe I notice it more because I'm such a car nut and I do it for a living.

Looking through art libraries and bookstores, I see lots of information on architectural design and rendering, graphics, even fashion and computer illustration. Drawing cars is a little bit like all of these and more, but nothing exists to explain this fun and exciting activity. Maybe there is so little about illustrating cars because they're so dynamic. The plethora of car styles, and the shapes and sculpturing within those styles, can be intimidating. Add to this color, environment, direction of light, and surface finishes, and illustrating an automobile becomes complex.

Back when I was taking art classes in high school and college,,information on drawing cars was like sex: highly desired but impossible to get. I think art teachers looked upon it as a skill much like refinishing furniture or laying bricks, as opposed to an artistic endeavor. But to be honest, I think at least part of this was due to their inability to do it themselves. As a result, I was left to learn the intricacies of car illustration through my own observations, devices, and, ultimately, frustrations.

Before you is my earnest attempt to make this dirty little secret more attainable. A lot of information needs coverage in just under 150 pages, so I left a few things out, including painting or airbrush illustration. I felt the focus should be on drawing and the simpler techniques of rendering rather than these more rigorous methods. Besides, numerous books and magazines cover the principles of airbrush art and the painting that can be applied to cars once you know the information provided here.

One other thing not covered in this book: Your mistakes become your successes, because they teach you what not to do, which helps lead you down the correct path. My father told me early on that the mark of a great artist was one who could make a mistake look like it was meant to be there. I don't know what an accountant was doing advising his son on art, but he was right. Even if you don't make good out of a bad line, mark, or sketch, you most likely won't make that mistake again.

Drawing cars should be fun, but as with anything that's rewarding, it takes dedication. What activity worth doing doesn't? With the shortcuts provided here and the desire to do it, you can pick up the basics quickly. Hopefully, this will give you the impetus to continue. Practice and observation are the keys.

For those who pick up the basics offered in this book, there are chapters on schools and computer illustration. In the last decade, the computer has taken over almost every aspect of illustration to the extent that I have expanded this chapter. Most of the contributing artists featured have switched over to computers, some doing their drawings without ever touching pen to paper. The problem is that with so much new software, versions of software, and tools within that software, it's impossible to give you a step-by-step guide. So instead I've included lots of examples that show some of the ways you can create art on the computer. As varied as these styles are, there are still a zillion other techniques waiting to be wrung from the gray matter of many an artist.

My drawing abilities were more learned than endowed, which leads me to believe that anyone can learn to draw as well as the artists featured in this book.

A Quick History of Automobile Design

Except for a few amateur inventors who may have fastened a crude steam engine to a couple of bicycles in attempts to come up with horseless contraptions, most people who design vehicles—whether for land, sea, or air—started with a pen and paper. It's a basic that's there from the get-go: An idea must be drawn to give engineers and designers, all of whom are involved in a vehicle's development, an opportunity to see what the ultimate product will look like. And the ability to draw a car is the first link in a long and circuitous chain.

Before you attack the drawing board with all those ultra-futuristic ideas you hope will wow them in Detroit in the twenty-first century, stop to consider how

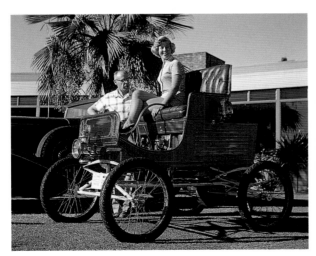

▲ Typical of the first horseless carriages is this Locomobile from the turn of the twentieth century. Powered by steam, the automobile's engine is directly under the driver's seat. This thing would be dangerous if it could attain any speed, but the first automobiles were as slow as they were crude. Bodies were wood, lights were actually gas lamps, and they were steered by a tiller.

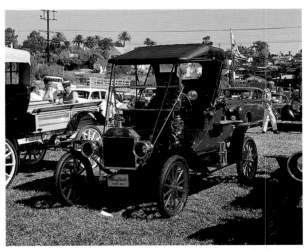

▲ Model Ts like this 1910 roadster brought the automobile to the masses—they literally put America on the road. Compare this to the Locomobile to see how much cars changed in just a few years. Ford made changes to this basic layout through 1927. Though very basic, this is essentially the same layout used in all cars right up to today.

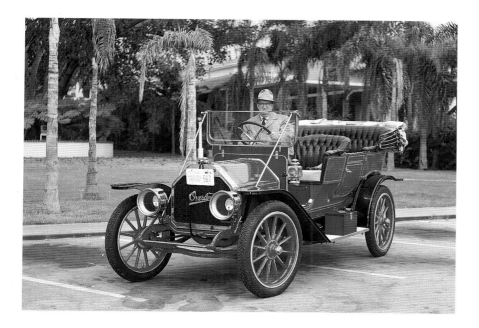

This 1909 Overland touring was just a bigger, beefier version of the spindly Model T. The transition away from doorless bodies was fairly complete by 1912. Many companies, including Overland, were either eventually absorbed by larger companies such as General Motors or went out of business around the time of the Great Depression.

automobiles—and you, if you want to get philosophical—got here. (Your dad probably went on a few dates with your mom before they got hitched, and he most likely needed a car to do so. Get it?) To understand why cars look the way they do, it is imperative that you know how the automobile evolved from its humble beginnings in the late 1800s to its high-tech forms of today.

In its infant stages, the automobile was just a motorized horse-drawn carriage sans horse. These motorized buggies took on all of their forefathers' characteristics—from simple, open buggies to the more elaborate closed versions resembling horse-drawn coaches. They stuffed their motors or engines under the body close to

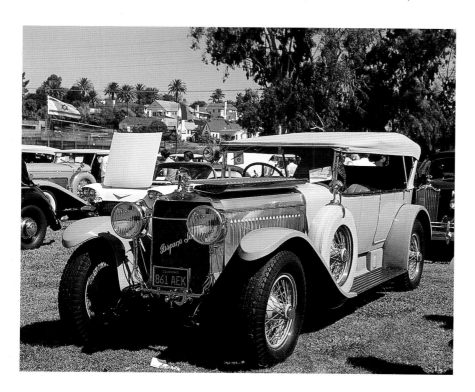

Notice how smooth bodies had gotten by the 1920s. Styling was beginning to take a part in the marketing and perceived value of cars. This French-built Hispano-Suiza touring sports a polished-aluminum hood, dual side-mounted tires, and a 37.2-horsepower six-cylinder engine.

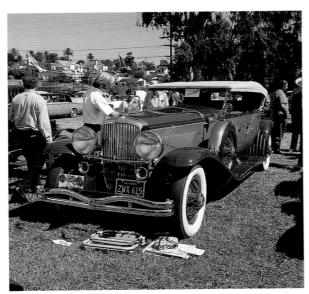

One of the truly classic makes was Duesenberg, represented here by this early 1930s phaeton. Notice the refinement of the body and how the fenders are becoming longer and more flowing in an attempt to visually lengthen and lower the form.

the rear axle, thus becoming the drive axle. Just after the turn of the century, builders started to position the engine up front, ahead of a flat board to protect the passengers from the oil, smoke, and noise. Known as a firewall, this board became a perfect place to attach a windscreen, or windshield, and instruments with which to monitor the engine functions. This changed the horse-drawn-coach look that automobile makers had adopted and ushered in the beginnings of what would become the more recognized automobile layout of today, with a frame mounting an engine up front, followed by a firewall and body behind.

Americans liked the idea of getting around on their own. Automobile manufacturers quickly popped up across the country, particularly in the Midwest and Northeast. As demand increased for the convenient and versatile automobile, car builders concentrated on the manufacturing and development of mass-production techniques, as pioneered by industrialists such as Henry Ford and Ransom E. Olds. With this focus on the mechanical and manufacturing, the car's appearance often took a back seat. Yet, as business died out for the carriage trade, many of the remaining body suppliers shifted gears and started doing business with automobile manufacturers; some became automobile manufacturers themselves. Among the new selling points for both the body builders and, ultimately, the car manufacturers, were refinements for ease of manufacturing and passenger comfort, and also for the look, or "flow," of the body surfaces and body joints. Even companies such as Ford, with its culture-changing Model T, were making running improvements to the appearances of its products.

The streamline era was starting to show its effects on automobile styling, as evidenced by this 1937 Cord convertible. Some consider this the most beautiful car ever produced. Pontoon fenders are integrated into the body, which itself absorbs the radiator shell and trunk. This car has no running boards, contrary to common practice with mass-produced cars until the 1940s.

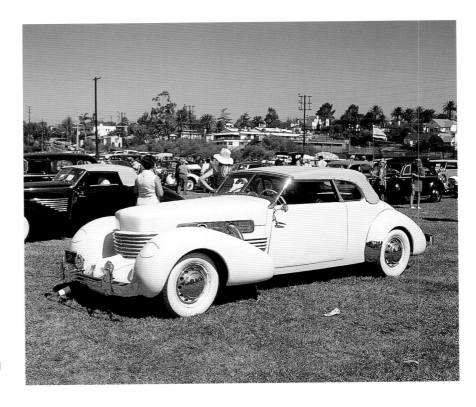

By the mid-1920s, appearance and style became as much a customer preference as speed, comfort, versatility, and overall size. Styling sold cars. As welding and sheet-metal-forming processes developed, builders could do more with the body of a car. Nowhere was this more important than at General Motors, where, in 1927, the company started its Art and Color section under the guidance of Harley Earl. With this step, GM had placed automobile styling as an equal to engineering and manufacturing in the development of an automobile. Styling soon would be a dominant factor in that process. This, combined with the "streamlined" revolution of the 1930s, led to the first golden age of automobile design.

Proportion, grace, and the sense of speed (or moving while standing still) prompted lower bodies and tops, pontoon fenders more integrated into the body, and wind-swept windshields and radiators. Long hoods, combined with fast-back rooflines, brought about a racy, fast look to automobiles, including Duesenbergs, Pierce-Arrows, Cords, and Cadillacs. More section or curve was becoming evident in the body sides, while running boards were slowly melting into the bodies when their usefulness disappeared as cars got lower. Designers attempted to tie the car together as a whole, to integrate components such as the grille, fenders, and trunk, as opposed to designing them separately. As the 1930s neared their end, the overly organic, voluptuous shapes were slowly sprouting creases and becoming flatter, blending and melting shapes and components into one another. Headlights, taillights, and windows were becoming part of the body surface.

World War II had the twofold effect of cutting off Europe and its influence on American design and shifting everyone's focus to the war effort itself. Car production ceased from 1942 to 1946. When it resumed, manufacturers sold prewar designs for a couple of years until they could gear up for something new. That something was a more "monocoque" or "soap bar" look, heavily influenced by wartime aircraft. As the 1950s approached, limited ornamentation, combined with a lowering of the beltline and tying the headlights and taillights to that line, created a square-shouldered, clean-and-lean look. Europe was also influencing American car design again. Low-and-flashy sports cars were all the rage in Europe, and American designers were anxious to apply that style to the more-accepted larger cars built in the United States.

By the mid-1950s, car design got crazy. Exhibiting all the exuberance and optimism extant in America after the war, large, sculpted, be-finned behemoths prowled America's highways. Whenever possible, elements were used in a car's design to give it exaggerated and enlarged character and identity. It was a wild and wacky time for automobile styling that, in retrospect, looks playful and flamboyant compared to today's cookie-cutter, rigidly designed cars. Sure, they were excessive, but they represent a time that was full of energy and optimism, and they reflect it in fashion and industrial design, automobiles included. Cars were becoming much more a personal statement and far less a mere appliance. The buzz words of 1950s car design? Low. Entertaining. More chrome. More glass. More overhang. More width. More . . . everything!

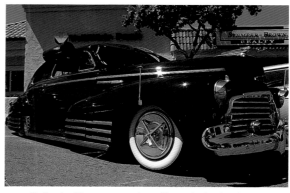

▲ Styling had become a major selling point by the time this 1942 Chevrolet Fleetline was produced. This car also represents the last of the American cars produced until after World War II. This accessory-laden aeroback example even sports an early version of air conditioning, seen hanging from the passenger window. The chrome trim was angled just right by GM's designers to catch people's eyes in sunlight.

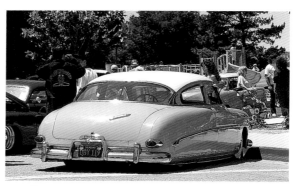

▲ The soap bar look is nowhere more apparent than on this 1953 Hudson sedan. Introduced in 1948, Hudsons were the first mass-produced cars to feature unit, or "unibody," construction. The floorpan was dropped between the siderails so that it was lower than the doorsills. This allowed for a lower car overall and added fuel to the longer, lower, wider revolution of the 1950s.

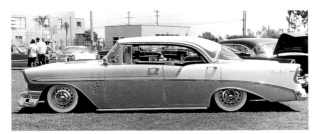

▲ This Chevrolet Sport Sedan represents the middle year of Chevy's 1955-1956-1957 triumvirate. Following the conservative period immediately after World War II, styling took a dramatic turn toward more exciting exercises by the mid-1950s. With such flamboyant features as tri-tone paint jobs, reversible seat cushions, and lots of chrome, the 1950s brought consumers more than they ever could have imagined. By mid-decade, vestiges of fins were showing up on all makes, with 1957 officially launching the who-can-produce-the-tallest-fins race.

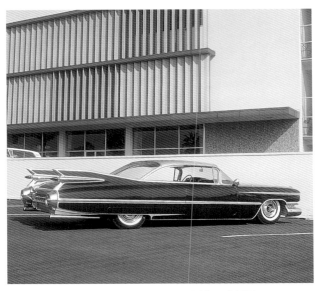

▲ The 1959 Cadillac is the quintessential finned 1950s car, represented here by Larry Watson's mildly customized coupe. In most cases, by 1961, the fins were gone, illustrating how critical styling and change had become to the auto industry. New designs were introduced yearly, much to the delight of jaded, car-crazy consumers tired of the previous year's models.

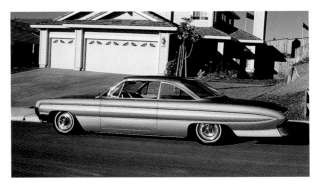

▲ By 1961, most fins had been snipped, although, in an odd twist, some makes sprouted smaller fins on their lower quarters. An example of the combined severity of both of these interesting features is seen on this 1961 Oldsmobile. Styling was becoming a bit more refined, with the long-hood and short-deck proportions ushered in by the 1964 1/2 Mustang that led the pony car stampede.

As the fashion pendulum seems to swing in extremes, cars were subdued in the 1960s (unlike some of the psychedelic-oriented and psychedelic-induced designs of that time), with safety, emissions, and government regulations becoming factors in car design. Designers combined hard edges with a more-sculptured overall shape in an attempt to distance themselves from the extremely sculptured and finned designs that so clearly marked the 1950s. Classically proportioned "pony cars," with their long hoods and short decks, emerged on the car scene starting in the mid-1960s, as was an emphasis to integrate the body and top C-pillar into one continuous surface.

The exploding popularity of the Volkswagen Beetle launched a revolution toward a more utilitarian approach to car design and packaging. The demand for economical, well-built cars like the Beetle and those products coming from Japan caught Detroit off guard. The effects are still felt in American automobile manufacturing today. Car design was headed toward a flatter, slab-sided type of body development, reaching its zenith with the Giorgetto Giugiaro-designed Volkswagen Rabbit in the mid-1970s. By the end of that decade, car designers were hiding bumpers behind flexible bodywork for a continuous envelope from front to back, and chrome had virtually disappeared from the automotive scene.

Two events heralded car design in the 1980s: the 1982 Audi 5000 and the 1986 Ford Taurus. Both cars exhibited more rounded or organic styling combined with flush glass. With an easing of U.S. federal regulations, both cars used flush headlights that conformed to the body. Though criticized by rivals as "jellybean" designs, the impact of these two designs will be felt through the end of the century. Most car companies have developed new shapes, with even more extreme organic designs entering the marketplace. Some designs from Chrysler have ushered in

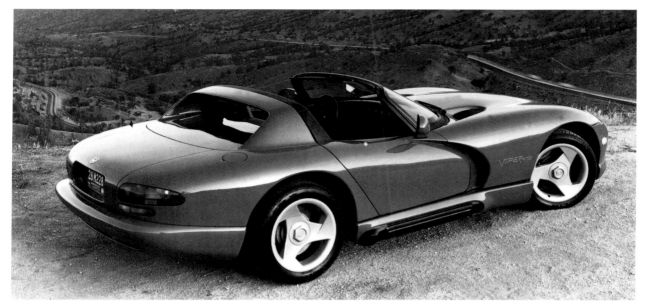

▲ Though not representative of the car most people drive, this Viper convertible is indicative of the return to more organic shapes witnessed through most of the 1990s and into the twenty-first century. As the pendulum of automotive-design trends tends to swing in extremes, don't be surprised if the car companies start moving away from this look in the near future.

the cab-forward proportions as the design wave of the future—which leads us up to today.

Some would say that the surge in popularity of sport-utility vehicles and pickups is a reaction to the current crop of domestic and imported "cookie-cutter" cars. Others believe that we are approaching a period much like the mid-1950s, where organic and sheer designs will converge, resulting in a more playful approach to design.

Wherever automotive design is headed, there is that inexplicable attraction that leads many to view cars as high art and prompts us to get involved in their design by drawing them. And this is where we begin.

Tools and Equipment

If you own pencils and paper, then you have the basics to draw anything. Right? Actually, there are many tricks that will help make your drawings and sketches easier to do, look more professional, and help you do them in less time. One trick is to have a comfortable, well-lit work area and equipment that will enhance your ability and desire to draw cars. Be forewarned: Having this equipment without knowing drawing basics won't help you a bit, just as the best bat, glove, and uniform do not make for the next Derek Jeter. This analogy holds true for computers, too, but more on that in Chapter Fifteen. All this equipment is an aid, not a replacement, for your drawing abilities.

First, you need a good drawing surface on which to work. A solid table, desk, drafting or light table is the preferred choice. Whatever your decision, the key word is sturdy. Don't settle for one of those wobbly, bottom-of-the-line drafting tables with the hinge-and-catch brackets that have been known to amputate

▶ There are so many choices when it comes to drawing utensils that you'll never know what they all do. Different pencils and pens yield different results, so it comes down to how comfortable they feel, the types of lines they create, and their performance in terms of drying, consistency, flow, and endurance. The good part is that they're usually cheap, so experiment with as many as you like!

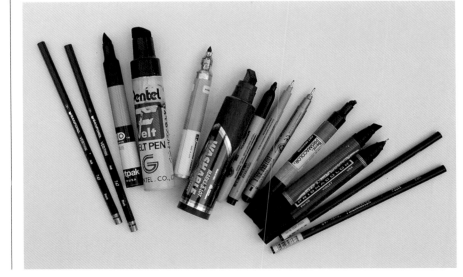

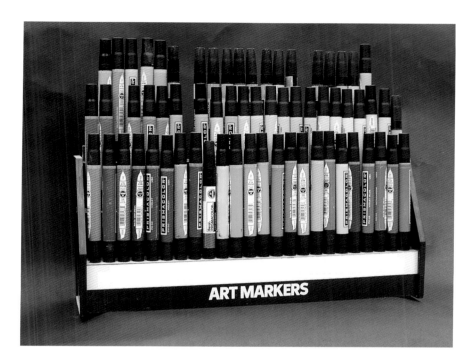

This is just one of the banks of colored markers I have to give me the widest range of colors and functions. Different brands of markers have pluses and minuses, so try a few different markers until you find the brand that works best for your needs. In terms of your health and the environment, the alcohol-based markers are better than the chemical-based ones. Lately, I have been able to find only the alcohol-based ones at the local art stores. If your local store is limited in its choices, try the Internet, where lots of art distributors sell their wares.

whole arms and hands (just kidding). Make sure its left edge is straight and square so you can run a T-square along this edge when you need to square things up on your drawings. If you need a surface that tilts, a drafting table is your best bet.

Whatever drawing surface you work on, having good lighting is best, for obvious reasons. I like incandescent lights, but you may wish to combine fluorescent and incandescent lighting, or prefer working under fluorescent conditions exclusively. Lighting should be even to avoid shadows or hot spots, so more than one light source will work best to spread out the light. I have three lamps at my drawing board. An articulating light is best for the occasional need to zone in for close-up work. Let's face it—you have to be able to see what you are doing, so start with a well-lit work space.

As for your implement of choice, experiment with different types of pens and pencils until you find the one with which you are most comfortable. I based my choice of Verithin 747 black pencils on the fact that they smear less, put down a nice black line, and don't break as easily as a lead pencil (I guess I have a heavy hand). Also, I find I have a bit more control with them; they tend to put out more resistance so my freehand line doesn't blast out of control over the paper. You may prefer the qualities that a No. 2 lead pencil offers, or a fine-tip pen, or even a ball-point pen. I know people who sketch with each of them, and they can all produce nice, "juicy" sketches.

If you use any type of wood pencil, you must have an electric pencil sharpener. Taking the time to sharpen a dull pencil after a few strokes is as annoying as an oil-down after each round of drag racing. And in such a circumstance, you are more likely to run with a dull pencil, which will produce a marginal sketch at best. Why do you think they call them dull? Step up and get the electric sharpener so that you can flog away.

Once you start to tighten up your sketches, you'll want to look into templates and angles to help guide you and your pencil. Forty-five-degree and 30/60-degree angles come in a variety of sizes; one of each angle will work just fine. Although the colored variety of angles looks cooler, stick with the clear ones, as it's easier to see your work through them.

A small assortment of brushes can be used not only for putting highlights into your drawings with white gouache, but also for actually drawing with. Examples of this can be found later on in this book.

▶ Sets of ellipse templates are available in 10- to 80-degree ranges, as well as in a range of sizes. Start with the smaller set first, then see where your needs take you. Chapter Five is devoted to ellipses.

Templates consist not only of the circle and ellipse variety, but also include French curves, or "sweeps." The ellipse templates come in sets ranging from 10 to 80 degrees; 100 degrees is a full circle. Sizes within the range go from 1/4 to 2 inches in the smaller template set. Start with this smaller set first and see if you have any need for the larger set, as it can be a bit pricey. These larger ellipse sets range in size from a 2- to 4-inch ellipse. They are great for larger drawings, but you may find you are more comfortable drawing smaller, in which case you won't need the larger set at all.

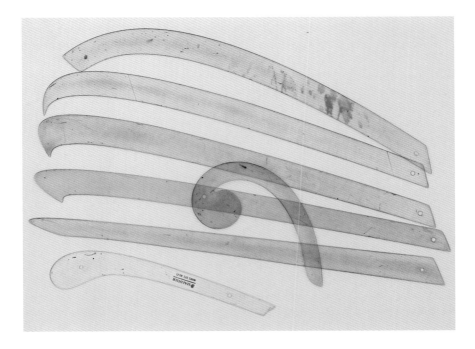

▶ To draw cars, you might think an artist would need the most contorted and twisted set of sweeps available. It is just the opposite. The almost-straight sweep in the photo is the one I use the most. Because I made these particular sweeps, they are not available commercially. Try to find close duplicates.

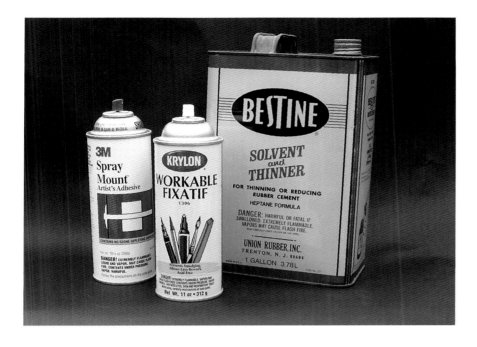

◀ Keep a can of Bestine handy for cleaning dirty sweeps and other instruments you gunk up with marker juice and pencil lead. It can also be used to create interesting backgrounds. A spray bomb of fixative works well to keep pencil or chalk down on your drawing, thus reducing instances of smudging. It also allows you to come back into the sketch and work in these sprayed areas later on.

As for French curves and sweeps, they will help in tuning up a line. They should not be used as a replacement for freehand drawing but as an enhancement. Most art stores carry a range of configurations from which to choose. Though the more complex and irregular curves look intriguing, try to find curves that display slight bows and gentle curves. These adapt better to car illustrations than the crazy-curve variety of French curves. I made the sweeps I use as a school project many moons ago. You can't buy them, though I've seen similar examples from time to time. They are about 20 inches and work perfectly for car illustration and design. Check out the photos and see if you can find something that looks similar at your local art store.

Templates and T-squares get dirty. A good solvent or thinner like Bestine dumped on some tissue works great to clean up your smudged and dirty equipment. Do it often while you are in the middle of a drawing. Nothing looks worse than a smeared and dirty drawing caused by filthy hands and equipment. Don't be lazy— keep those hands and tools clean!

▼ You'll not only erase with these pencil-type erasers, you'll also create highlights and reflections by removing drawn or rendered material from your paper or board.

Other small but necessary items to have on hand are a variety of erasers. I prefer the Pink Pearl and white vinyl type in pencil form. Since you probably will have a specific area you wish to erase, these thinner erasers get in that small area and do the job. The larger Pink Pearl and kneaded gray erasers take no prisoners. When you erase, they go for it all. Not good for tight spots! Stick with those slender ones. Some have a peel-back outer skin, while others insert into a plastic holder. You may want to use a controlled erasure to create a highlight (more on this in Chapter Ten). Slicing off the end gives you an incredibly sharp edge to erase with, which leads to a crisp erasure. To get that clean slice you will need to purchase an X-ACTO knife. These razor-sharp knives have myriad uses, from cutting eraser

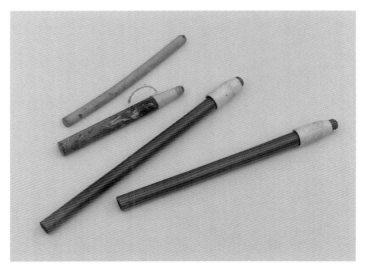

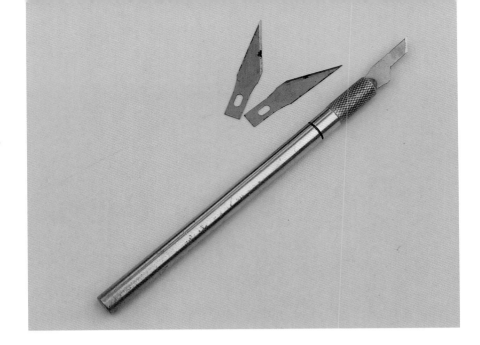

▶ An X-ACTO knife is a must-have item for the budding artist. Different blades give you different types of control. The knife is used to cut masks, scrape chalk for backgrounds, and much more.

▼ Good reference materials in the form of photos, clippings, magazines, and books are essential to expand your knowledge of cars. In most cases, such references are rich sources for determining reflections, shadows, color, and light. They also can become a basis for going beyond reality once you start experimenting with your car renderings.

ends and matte board to scraping dirt spots off negatives and film positives. Just be careful. They slice through skin as if it were butter!

Masking tape also comes in handy, but I prefer drafting tape. It sticks less so you can get it off your paper or board without destroying your latest creation. But there is also another reason. Some artists use the stuff to mask off an area of the drawing much as you might use frisket or masking film. (Frisket is a brand of thin vinyl film with an adhesive backing that you cut to a specific shape to protect or isolate an area on which you are working.) Some artists use it to mask off the paper around the image they're drawing to keep it clean from fingerprints and sweaty hands. In Chapter Ten, I'll show you how to use Nitto tape, which is similar to frisket without the peel-off backing. Since masking film can be a bit expensive, you may want to practice with the drafting tape first. Then, as you feel the need to be a bit more discriminating, you can try out the variety of film available.

Finally, you'll need something on which to draw. Zillions of paper types and illustration boards are available to suit every desire. Start with a couple of different bond paper tablets at least 9x12 inches or larger. You will find that paper varies in texture, thickness, and shades of white. Some take pencils better; some take markers or chalks better. You'll need to experiment to see which type best fits your particular requirements. As we get into the actual drawing portions of this book, I will suggest certain types of paper or board that work well for those applications being discussed. But the real joy in drawing is to tailor your choices to what works best for you.

Perspective

Beginners cringe at the thought of perspective, but you have to admit it's very cool once you see that car sitting on your paper like it was a real three-dimensional object! You don't want to be drawing side views all your life, so get through this chapter and apply what you have learned to your next car drawing. You've heard it before: You'll improve with practice.

There is a mechanical way to draw in perspective, but it is a methodical process that does not allow for exaggeration or emphasis. Simple steps are covered in this chapter, but the best advice is to look with your eyes and brain, to visualize what it is you wish to draw. Relying on methods and plotting slows the drawing process and does not make for a fun drawing experience.

To begin, you must make some decisions. The first is to select which view of the car you would like to see. This will determine how much of the front, side, or back of the car you wish to show. Usually, what is known as a "front 3/4 view" is

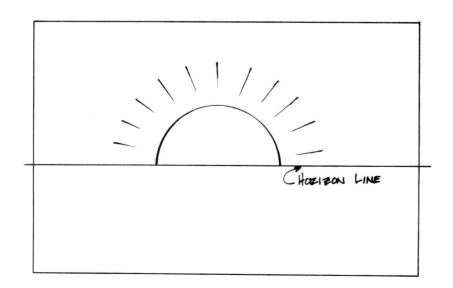

◄ When placing an as-yet-to-be-drawn object on a flat plane, the horizon line will dictate the view, or eye level, of your object. An artist represents linear perspective by pointing all lines in this imaginary space toward a vanishing point. The borders represent the limits to the space we are creating within it, and the rising sun represents the beginning of your journey to drawing cars properly.

► Parallel, or one-point, perspective is best illustrated by the converging train tracks. Lines aimed at that point give the object and space the illusion of being three-dimensional. The dotted lines show that convergence.

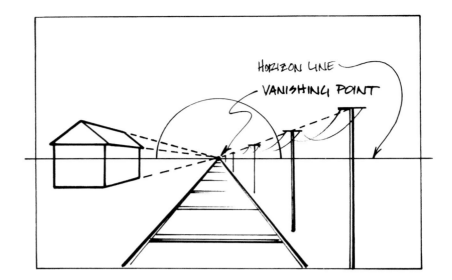

the most common angle chosen to draw cars because it tends to give the best sense of how the car looks. Next, you must choose the viewer's angle. Do you want to look down on the vehicle, as if from a tall vantage point, or see it much like you would if you were walking along a street? Or right at it, as if you were on your hands and knees? Or from a worm's-eye view, or what is called a "ground-level" view? This will determine the horizon line and vanishing points.

The horizon line is that point out in the distance where the sky and ground meet. Hypothetically, if it is a clear day and you are looking across an uninter-rupted stretch of desert or field, it is the line in the distance at which the sky meets the field or desert floor. Obviously, the horizon line is rarely seen in real life because it is usually covered up by buildings, trees, walls—you name it. Yet, if you are to construct an accurate drawing of a car and/or its surroundings, you need to draw or at least visualize this line. It is usually placed in the middle of a page, but its location determines how the car is viewed. A low horizon line will result in a view looking down, a high horizon line will give you a worm's-eye view of the subject, and in between will give you variations of these two extremes.

► Lines that vanish in two directions illustrate angular, or two-point, perspective. This is a truer simulation of reality than the one-point perspective example and is the setup for virtually all vehicle depictions. As the objects go back into our space, they foreshorten. This means they shorten up because we actually see less as their sides angle away from us.

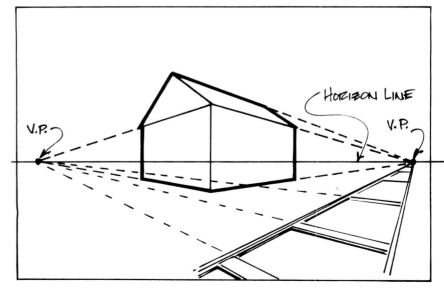

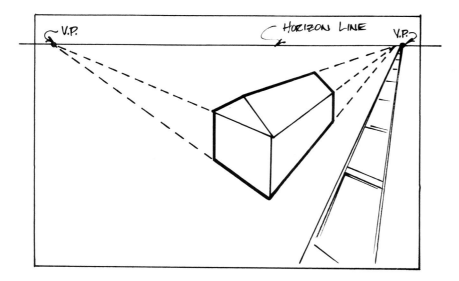

◀ Moving the horizon line to the upper portions of the space we have created yields a higher view than the previous example, which put the eye level right at the horizon line. This higher view is a good perspective to illustrate an interesting feature on the hood of the car. It also allows you to see through the windshield.

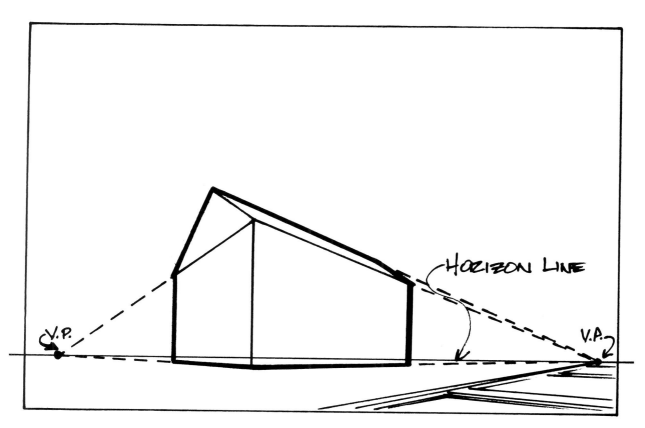

The vanishing point is that point at which the lines of a diminishing object disappear at the horizon line. But this description is a lot more confusing than the simple example of the train tracks. The vanishing point for train tracks is that point at which the tracks come together out in the distance at the horizon line.

There are really only two types of vanishing point setups. The first is the single-point perspective, where only one vanishing point is used. The railroad track scenario fits this example best. Next is the two-point perspective, which is the usual method used to draw a car. Rather than describe it here, the accompanying

▲ A low horizon line gives you a low, or worm's-eye, view of the object. With the vanishing points within the space we have created, the object is given a very forced and extreme look.

▶ A better solution to perspective may be to place the vanishing points outside the borders of our space. This gives a more realistic view of the object. You may want to practice placement of both the horizon line and vanishing points to see some of the different possible setups.

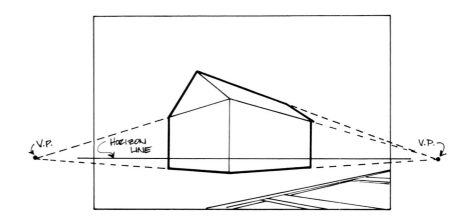

examples will help you better understand the two-point perspective and how it relates to drawing cars.

Objects in perspective lose detail and value as they go back into the atmosphere of the imaginary space you have created in your sketch. Atmosphere softens the details and lightens the values. To visually pull an object toward you, adding more detail and value are two of the several things you can do to trick the eye. This works in the artist's favor, as it becomes unnecessary to put as much effort into the detail of objects farther back in perspective.

I talk about value here and throughout the book. Value refers to the lightness or darkness an object exhibits either in color or in black and white. Pastel colors, yellow, and definitely white have light values. Orange, most reds, greens, and blues fall into the medium-value category. Purple and the darker blues, reds, greens, browns, and especially black all exhibit a darker value.

We assign numbers for values in a gray value scale from 1 to 10, with 1 being the lightest value and 10 being the darkest. You can see how value is assigned to a car rendering in Chapters Seven and Eight.

▶ Although not usually applicable to drawing cars, I thought I would at least clue you in on three-point perspective, a trick artists use when trying to give an object the sense of being very large. You see a lot of this used in comic books, where there is a lot of action and drama that needs to be conveyed within the panels of the stories.

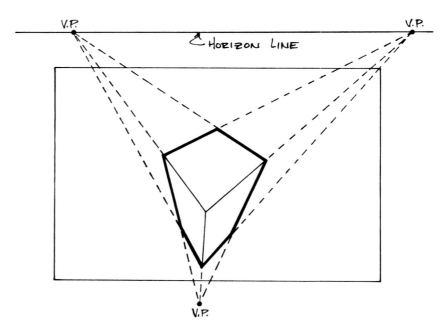

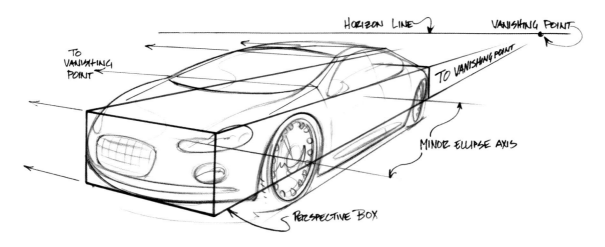

HORIZON LINE

VANISHING POINT

TO VANISHING POINT

TO VANISHING POINT

MINOR ELLIPSE AXIS

PERSPECTIVE BOX

▲ Applying what we know about perspective to this Chrysler show car, first we need to determine our horizon line, vanishing points, and view of the car we wish to depict. The minor ellipses axes determine where the wheels go and how they are drawn; more on this in Chapter Five. The heavy box drawn around our car shows the perspective setup. Some artists start with a lightly drawn box as a perspective guide before drawing the car. Then they erase the box after they are well into the sketch.

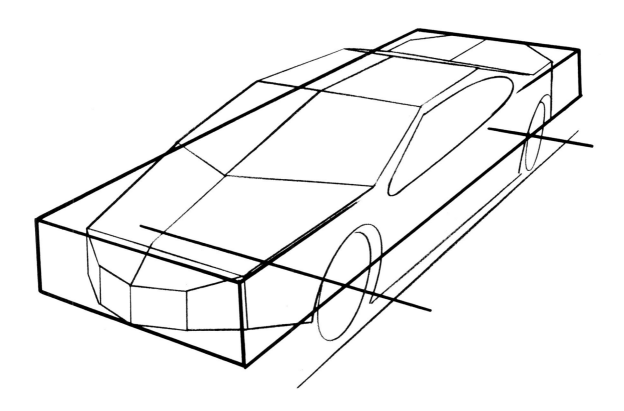

▲ Showing our car in simplified flat planes, we see that our horizon line has been moved up for a higher eye level—in other words, looking down on our subject. Again, the box shows our perspective setup.

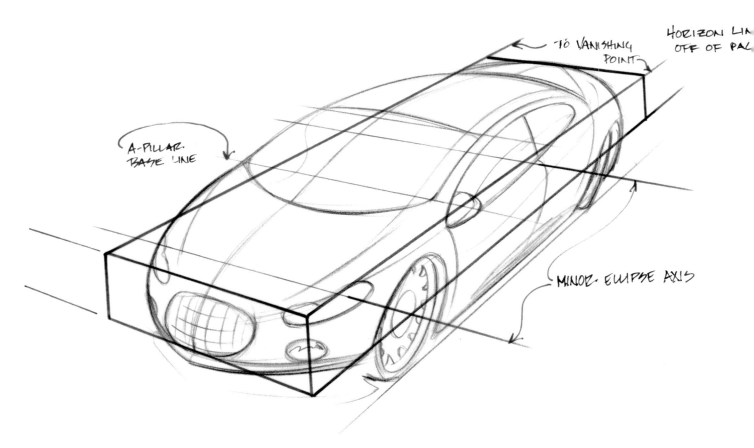

HORIZON LIN
OFF OF PAC

TO VANISHING
POINT

A-PILLAR
BASE LINE

MINOR ELLIPSE AXIS

▲ With the planed surfaces smoothed out to represent a real car, you can see how the car takes shape and how it is depicted from a different vantage point than the first view in this series. Organic cars like this one are a bit more difficult to draw. If you have problems, try practicing with a flatter, more angular car.

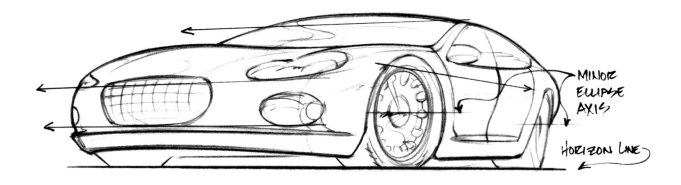

MINOR
ELLIPSE
AXIS

HORIZON LINE

▲ Our Chrysler from yet another vantage point, this time almost a worm's-eye view. Indicating the box in this view would be confusing, so it has been left out, but the arrows show where our perspective lines converge—which is waaaay out beyond this book. The view makes for a very powerful and dramatic setup.

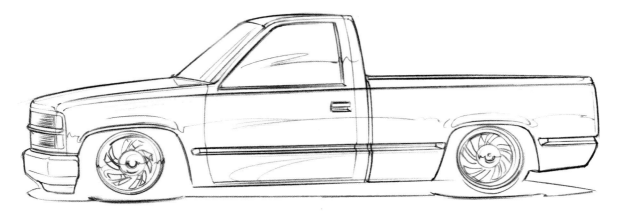

▲ This side view gives us a starting point for determining details before we spin it into perspective. Again, at this point we will need to choose where to place the horizon line to give us our eye level, as well as which view of the truck we will want to show.

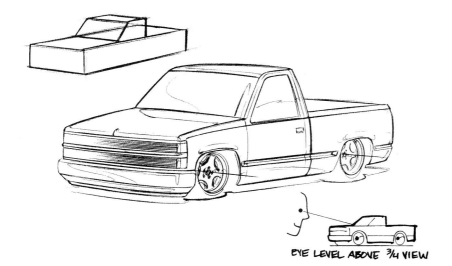

◀ The simple box drawing shows the view and the basic perspective setup. The cartoon gives the eye level, which places the horizon line a little above the middle of the space we have created.

EYE LEVEL ABOVE ¾ VIEW

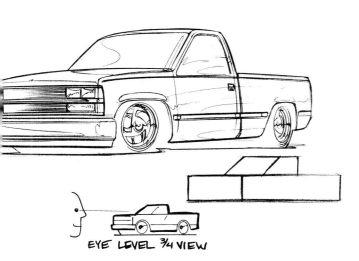

EYE LEVEL ¾ VIEW

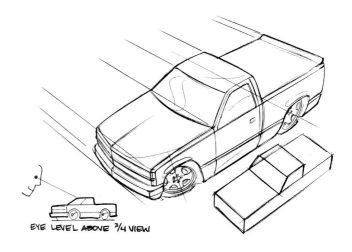

EYE LEVEL ABOVE ¾ VIEW

▲ A low horizon line gives a ground or low eye level. The box drawing shows the perspective lines are almost parallel. This happens when our eye level is in the middle of an object, as shown in this cartoon. With the perspective lines parallel, this becomes the simplest perspective to create.

▲ With a high horizon line, we look down on the truck. The sides of the truck foreshorten, which means that, due to our extreme eye level, the sides get shorter to our eye. Also because of the eye level, the ellipses we use to create the tires and wheels are tighter. See Chapter Five for more on circles and round objects in perspective.

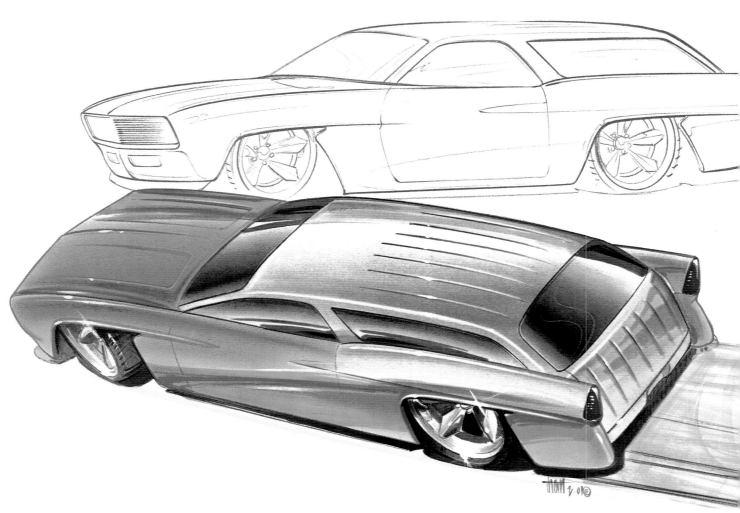

▲ This is an example of two great views—one is an easy horizon-through-the-middle setup like we did earlier in this chapter, while the lower is quite descriptive but a little more work to set up perspective-wise. The vanishing point for the lower view is way off of the page, which you can tell because the converging lines are almost parallel.

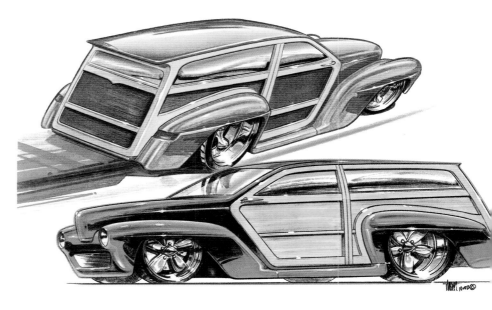

▶ The woodies shown are set up similarly to the previous green wagon and its accompanying sketch, but with slightly less tip-up to the orange rear 3/4 view. Together, these two views are very descriptive of the woody's design—you almost don't need any other drawings to see what this car would look like when finished.

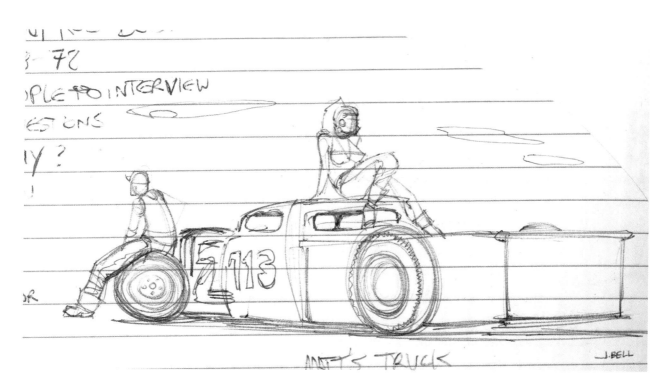

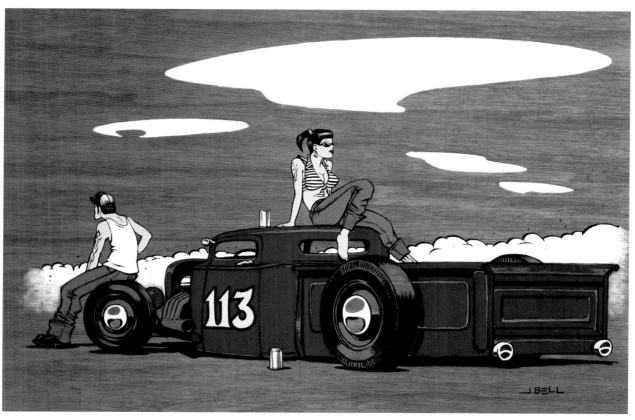

▲ John Bell's painting entitled *Matt's 113* is an example of sticking the viewer and the object right on the horizon line. You only need to worry a bit about converging lines in this setup. You can see in the thumbnail sketch how the notebook paper lines act as guides. The car is still in perspective, but without much concern for converging lines. This setup may be a good way to initially tickle perspective, but you'll need to branch out soon enough, so don't get stuck doing this type of view exclusively. John doesn't.

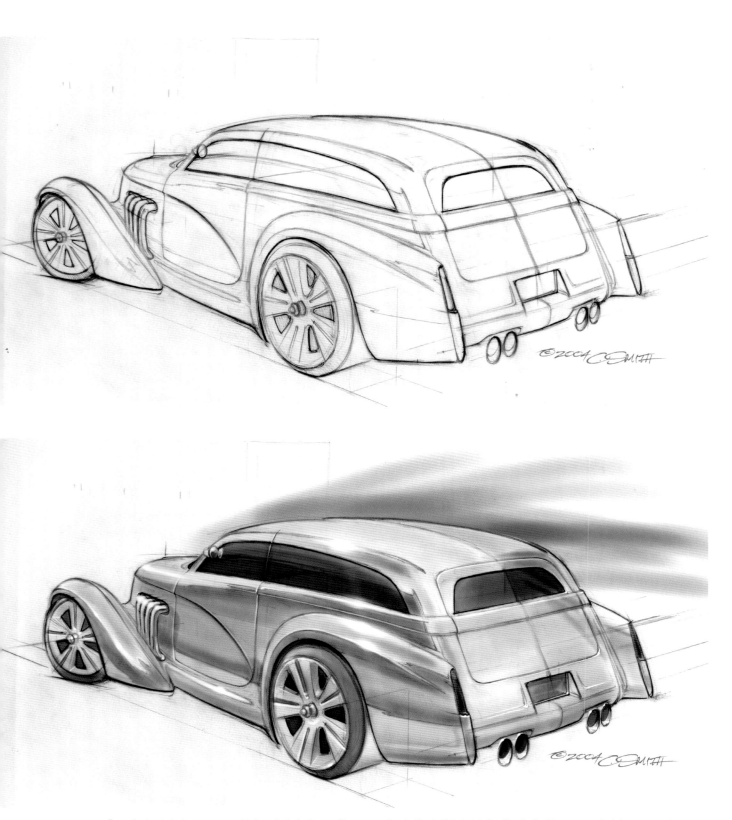

▲ Even the best designers use guidelines to help them with perspective. In the initial sketch by Charlie Smith we see all of the perspective guidelines—even those that show the centers of surfaces. Also, he includes the minor axis for the wheels. Carried over into the final computer sketch, the guidelines really are not offensive when left in. There could be a final phase where he erases those lines, or this may be it. Either way it's a cool car and a cool drawing!

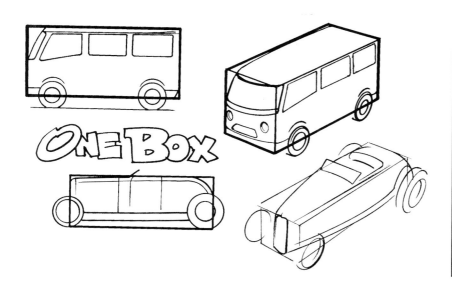

Proportion

Y ou may have heard the term "proportion" bandied about when describing that latest mouth-watering creation from Car Land and wondered just what it meant. Proportion refers to the relationship to one another of the visual elements that make up the car. We're talking about the side windows, their size, and how they relate to the body; how the size and height of the body relate to the top or wheelbase; or how the overhang at the front or rear of the car looks in relation to the body, the top, or the wheelbase. The result of the relationships of these visual elements gives the car a pleasing balance or feel. The "feel" of a car can be a very subjective thing, which is why you see so many different types of automobiles on the road, from vans and sports cars to sedans and trucks. This is also the reason, within each of these categories, that we see so many variations in design and proportion.

◀ The building blocks of proportion are simple one-, two-, and three-box groups. Keeping these in mind should aid you in visualizing a car's proportions and serve as loose guidelines on paper. Included in one-box proportions are vans and even 1930s roadsters and tourings.

▶ Vehicles with two-box proportions include SUVs, station wagons, hatchbacks, and fastbacks. Also, any van with an extreme amount of front overhang falls into the two-box category.

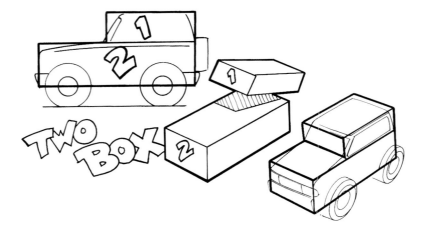

Proportions can also be slotted into three general categories, known as one-box, two-box, and three-box design. One-box design is made up of vans without any front engine overhang or crush zone, and I suppose you could include 1920s and 1930s roadsters here, too. Two-box design includes vans with a front overhang, station wagons, sport-utilities like Range Rovers and Blazers, hatchbacks, and fast-backs like those cool "aeroback" GM fastbacks from the late 1940s. Three-box designs are mostly sedans, hardtops, and pick-up trucks.

Paying attention to the proportions of the car you are drawing can partially determine whether it looks right or wrong. One of the easiest ways to ascertain whether you are on the mark in terms of proportion is to scale the car to an element of itself.

Huh?

▼ Three-box proportions are the most common, taking in sedans, coupes, and pickup trucks.

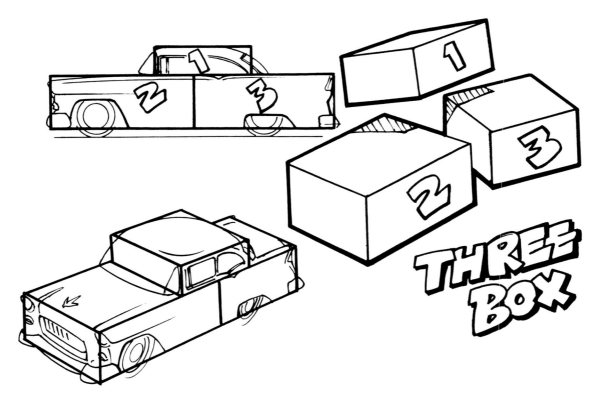

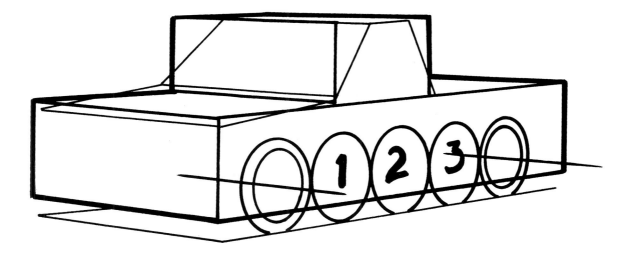

▲ Wheelbase is very important in determining the proportions of any vehicle. Using an element of the car you are drawing, like a tire, can be a terrific aid in figuring out the wheelbase and thus helping you with proportions. A general rule of thumb is 3 tires for regular cars and trucks, 2 1/2 tires for smaller cars like hatchbacks, and 3 1/2 or more tires for larger cars and limousines.

Well, you know that tires are mostly in the 25- to 27-inch range. You can use this as a means to scale your drawing. In other words, to measure dimensions roughly. We're not talking about an accurately scaled diagram, just a quick-and-easy way to see if you are in the range of acceptability with the proportions you have chosen to draw. It's an aid that is both fun and easy.

An example: The height might be three tires high, the wheelbase five tires long, and front and rear overhang one tire each. Armed with this information, you now have an aid to spin that car into perspective and have it turn out in proportion. Of course, proportion is another common problem in drawings that are not done properly, whether by an amateur or professional. Exaggerating proportion is also one of the first things relied upon to turn a drawing into a cartoon.

Another method is a grid system based on a side view of the car. Not as methodical as perspective plotting, it is a helpful guide in giving your drawing a three-dimensional look. Draw a box around your car's side view and grid it off in some convenient division. Then draw the box and grid lightly on your paper, in perspective. Since you should be able to place a box in perspective, this method allows you to use the grid within the box as your guide. Until you get comfortable with your "visualization" of the car you wish to draw, you may want to use this method as a means to get those proportions right.

▼ Gridding can sometimes help if you start with a side view. However, I find that this method takes a lot of time for what you end up with. I'll demonstrate it here, but be forewarned that I don't consider it the best approach for determining a car's proportions in perspective. Once your side view is determined, draw a convenient grid over it.

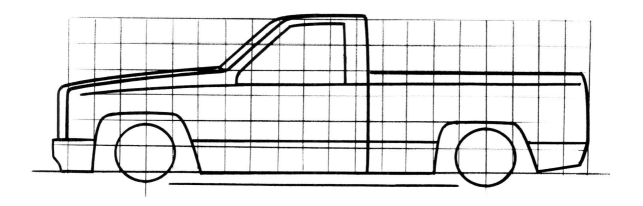

▶ Transferring the grid to perspective requires its foreshortening. Follow where the side-view lines fall in the new grid and you have a semblance of the side in perspective. Now, roughly build out from the side to the vanishing point to create your front end, hood, windshield, and the rest of the truck.

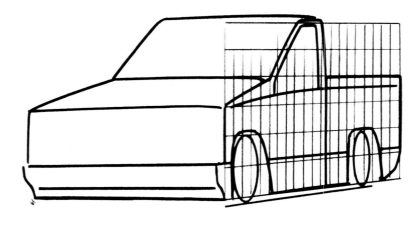

▶ Use your rough perspective as an underlay, or erase the grid and finish off the drawing. As you can see, we have a fairly good representation of a late-model truck. If used as a crutch for a short time, gridding is a good method to elevate your awareness of proportion and perspective.

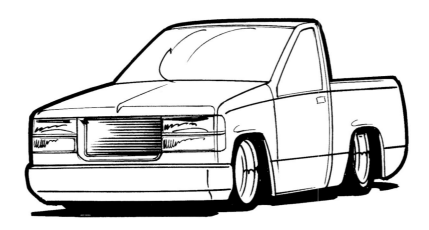

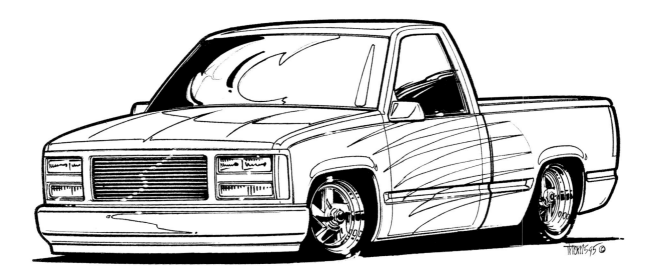

▲ It would be hard to achieve a drawing like this with the grid method, which is why I use it to make a point. This drawing was achieved by studying photographs and roughing out the proportions freehand. It took a couple of overlays before I had it in a form from which I could do a finished drawing. As you can see, visualizing, good freehand sketching, an understanding of proportion, and some time have given us a better truck drawing.

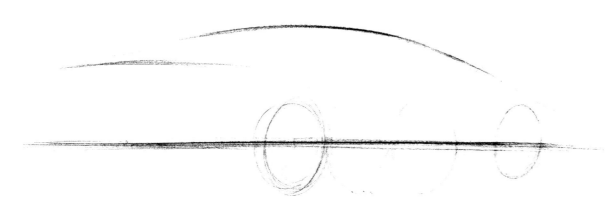

▲ If we jump ahead a bit and use sketching methods from Chapter Six, plus what you now know about perspective and proportion, we can see that there is an easier way to sketch a car. This is an especially good trick when your eye level is in line with the side of the car so that your perspective lines are almost parallel. Start with a line that represents the minor axis of the wheels and provides a guide for determining the three-tire proportions. Loosely rough out a silhouette or outline of the car you wish to sketch.

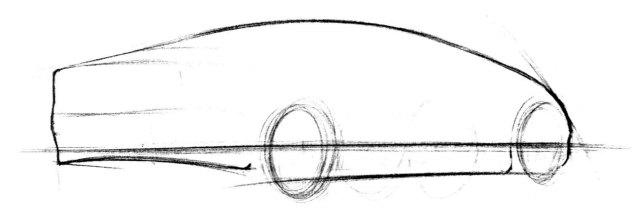

▲ Sketch in the bottom, or rockers, as well as a front and back. I draw these lines very lightly at first, then darken or tighten them up as I feel the car taking shape. We now have an outline that we will soon fill in with more details.

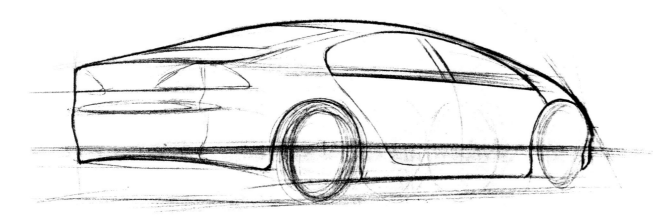

▲ Window lines, taillights, door cuts, and miscellaneous details start to give our sedan some life.

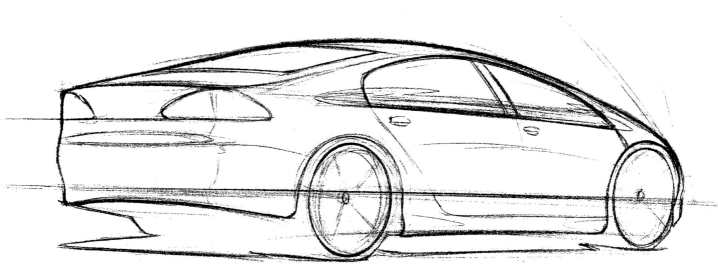

▲ Reflection and wheel design guidelines, as well as ground shadow, set us up for the final details.

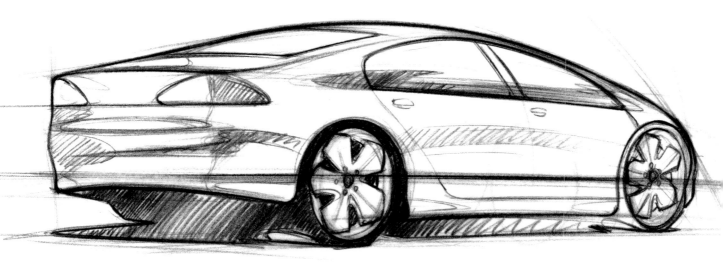

▲ Our finished sketch is the result of some perspective and proportion tricks, and also of feeling the sketch as we go.

Ellipses and Axes

Placing round or cylindrical objects in perspective is the most common mistake I see in drawings and illustrations, yet it is the simplest theory in practice. I guess they did not cover it in some art schools, or those without a firm grasp of the concept may not have bothered to analyze how to put a cylindrical object properly into perspective.

This is yet another easy method to pick up. Quite simply, an ellipse is just a circle in perspective. As you will see in the examples, the keys to putting a tire or steering wheel or any round object into perspective are the major and minor axes of the ellipse. That, and an intelligent eye, should work every time. The one point to remember is that there are no points on a cylindrical object in perspective except on a football! A tin can, bowl, or tire lying on its side—none of these objects have pointy ends.

With this in mind, refer to the drawings in this chapter for simple methods and aids to help you nail down this final technical portion of drawing, before we move on to some less-technical aspects of drawing cars.

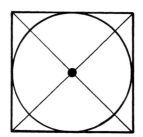

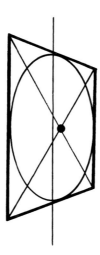

◀ Since it is easy to put a box into perspective, this is how we will begin in order to help us place circular objects like tires, wheels, and headlights into our 3-D imaginary space. The dot represents the center of the box in the first example, and the perspective center of the box in the second example. When the circle is placed into perspective, it becomes an ellipse. Notice that the ellipse is a continuous curve and that there are no points at the tight ends of the ellipse.

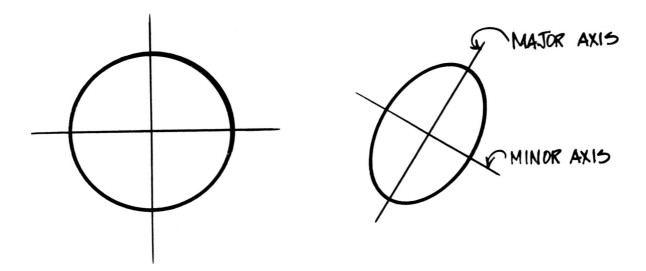

▲ Eliminating the box, we have a circle with its center represented by the cross lines. Flipping the circle into perspective gives us a better relationship of the cross lines, known as the major and minor axes. For car illustrations, we will be concerned mostly with the minor axis, as this represents the axle or centerline, which is always used as a guide to determine whether our wheels are in perspective or not.

▶ Creating a cylinder or a cone relies on the minor axis. In the cone's case, its point rests somewhere on the minor axis, depending on how tall you would like to make it. For our cylinder, the minor axis determines its far end, or end cut. Since the cylinder is going back into perspective, we have to converge our sides slightly, which means our far-end ellipse will be slightly smaller than our front one. Got it?

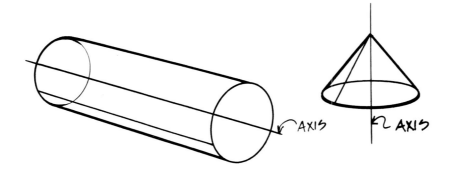

▶ Again, the minor axis is the guide from which we create a cocktail glass. Notice how the bottom ellipse is less pinched than the top one. This is because as we move down on the glass and away from the horizon line, we see more of the bottom.

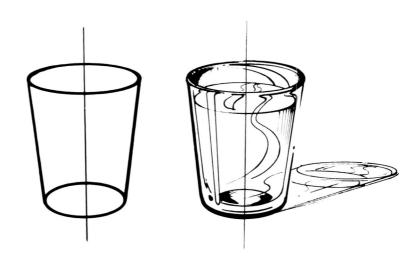

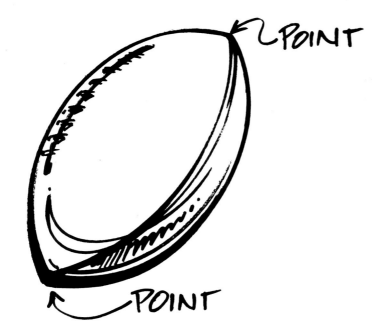

◀ Only footballs have points in perspective!

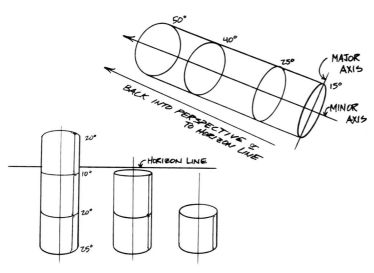

◀ Ellipses are identified by degrees, with the tightest being almost 0, which would be represented by a line and not an ellipse. A full circle is 100 degrees, represented by a true circle. As mentioned with the cocktail glass drawing, as circular objects move away from the horizon line, their degree of roundness becomes larger. A circle sitting on the horizon line becomes a line, or 0 degrees, while moving above or below the horizon line yields a larger-degree ellipse, increasing in size the farther you go.

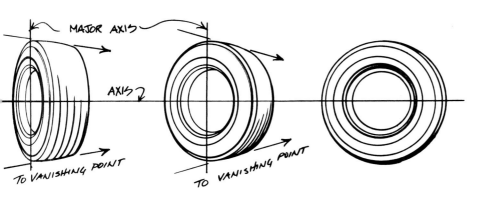

◀ A combination tire/wheel assembly is just a series of built-up ellipses. The vanishing points will dictate the angle that the face of the tire tread takes. Because the axis represents the center of the car's axle, it becomes the predominate concern when constructing a tire/wheel combination for your car drawing.

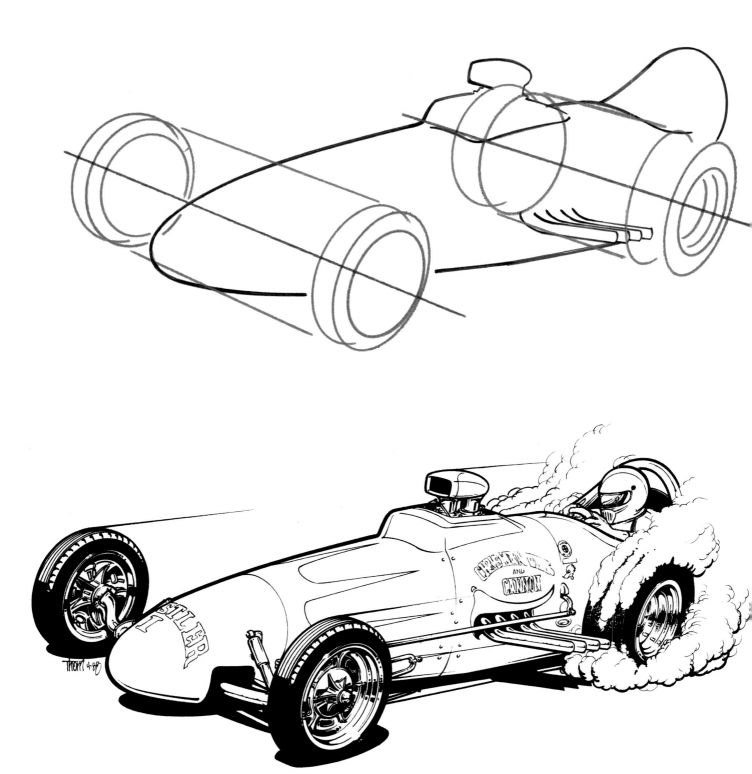

▲ The famed Chrisman and Cannon *Hustler* Fuel Dragster shows us how the tire/wheel assembly is set up in perspective. With the minor axis pointing to the left vanishing point, notice how the ellipses get smaller as they move closer to the horizon line. Moving toward the left vanishing point, our ellipses are less pinched, but moving toward the right vanishing point, we see less of the face of the tire and more of the tread. If we used the same ellipse for our two front wheels, it would give the illusion that the car was steering into itself—not good!

Sketching and Line Quality

Sketching techniques are as varied as signatures and in many ways are like a signature. The way a drawing is sketched can define who did the work by the particular technique and the artist's style. I'll get into the different types of drawing tools and how they can change an artist's style in another chapter. Here, I'll develop some basic suggestions to try out. The ability to sketch should come easily, so some of these suggestions may be too cumbersome for your own taste. Not to worry. Use what you can from this chapter, or try to adapt some of these suggestions to your own style of drawing.

▲ (Above and next page) Sometimes I'll do a couple of views for clarity, but I don't necessarily want to render them both. In this case, I did a slightly tighter line sketch of a second view. I may vary details or color to allow the viewer to see other possibilities. In the rear 3/4 view, I'm going for nice line quality, emphasizing some of the lines to indicate a surface turning under or a shadow, or just to help prop up something visually. The finished rendering like that on page 40 is as far as I normally go—marker, chalk, and a little colored pencil.

The main objective is to have fun and stay loose when you draw and sketch. A relaxed and free hand, drawing from your whole arm—even your whole body—instead of quick rips from the wrist, helps you maintain a nice flow to your drawings and results in more-controllable lines. You've seen the chicken-scratch style of drawing with short, quick strokes and jabs. My observations and practice of drawing styles have shown me that this style can be very distracting and less professional. You may want to pay particular attention to the way lines are delineated and also their weights and emphasis.

Line weights are the thick and thin lines you see throughout a sketch. Variations in line weight hold your attention longer and are a lot more interesting to look at than lines that are consistent. From the artist's standpoint, they are also more fun to create and are probably easier and quicker to do than a drawing with repetitive line weights throughout. Typically, you give more emphasis or line weight to a line that is closer to you, a line that helps to represent an undercut edge, an edge that is defining something round, or a part of a drawing that calls for some extra pressure. After all, it's as much a tactile experience as it is a visual one. Combine these elements and you have line quality.

A great sketch contains lots of different line weights that contribute to its line quality. Don't get bogged down by common weights. Give your drawing some spark and interest by varying those weights. You can feel the difference.

There are great examples of line quality shown throughout the book as we are fortunate to have many of the artists' preliminary sketches. So while viewing some of these drawings take note of the line weights and loose or tight sketching. I have also included a few examples we'll discuss here.

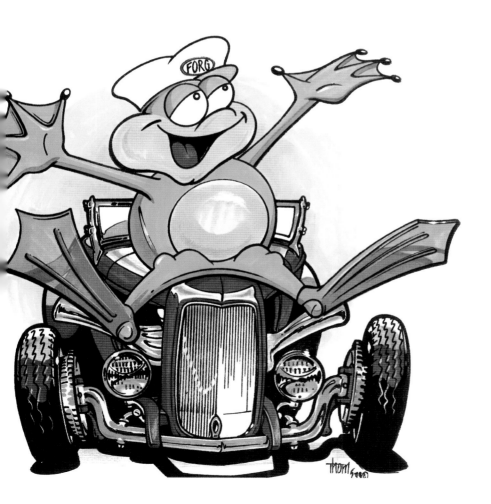

◄ Though this is a cartoon, I thought I'd show how a simple drawing was accomplished. The main purpose in showing these preliminary sketches is that you see that nice, finished drawings normally don't start out that way—they come from rather simple, crude sketches. This Frog Follies art started out with the cutesy scribbled frog sketch, then worked its way into becoming a frog on a roadster and, ultimately, the finished color rendering. The final was done in black line work and finished off with the color plugged in.

▲ Let's try a sketch that doesn't require drawing boxes for perspective help. This sketch will place our level right in the middle of the car, so we don't have to be as concerned with vanishing points. Remember why? Our line is the basis from which we begin our sketch. It becomes the horizon line, the approximate middle of the body, the location of the minor axis, and also the line on which we place our headlights.

▲ I've picked a point back from the headlight for our front wheel, and approximately 2 1/2 tires back I place the second tire in a somewhat tighter ellipse. This allows me to determine the approximate bottom of the car and a ground line.

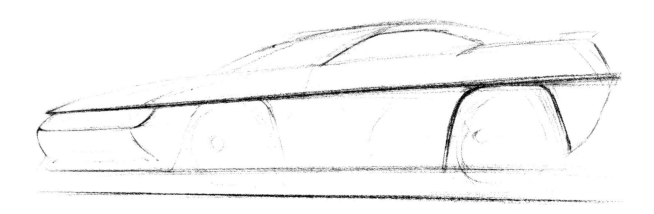

▲ We rough in the outline or silhouette of our car and indicate the windshield A-pillar location. If you do these stages lightly at first, you can change them later if you don't like where they fall.

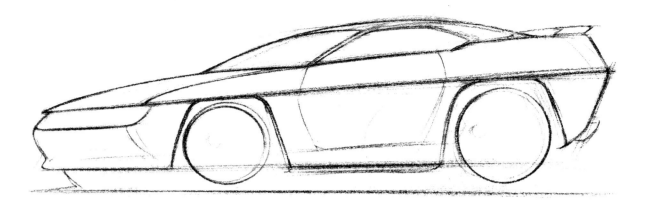

▲ Roughed-in wheel outlines, door indications, a side daylight opening (DLO), and rear exhaust start to bring our sketch around.

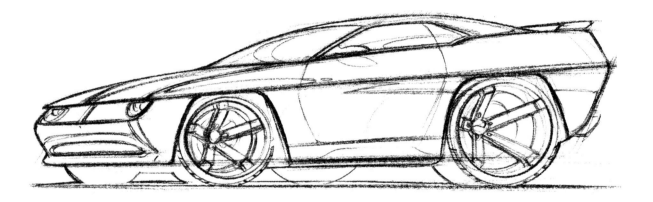

▲ Detailing out the front end and the wheels, as well as adding some reflection indication, just about completes the sketch.

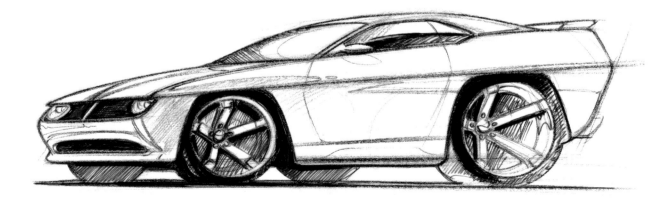

▲ A grille opening and some quick pen work completes our cool 'Cuda quick sketch.

▲ With little perspective to deal with, the previous sketch was almost like cheating. Now, let's put that same car into a real perspective and see what we get. Again, I begin with the line that will become the basis from which we build the car.

▶ As with the previous sketch, I use our center as a build-off point for my wheel placement and rough wheelbase.

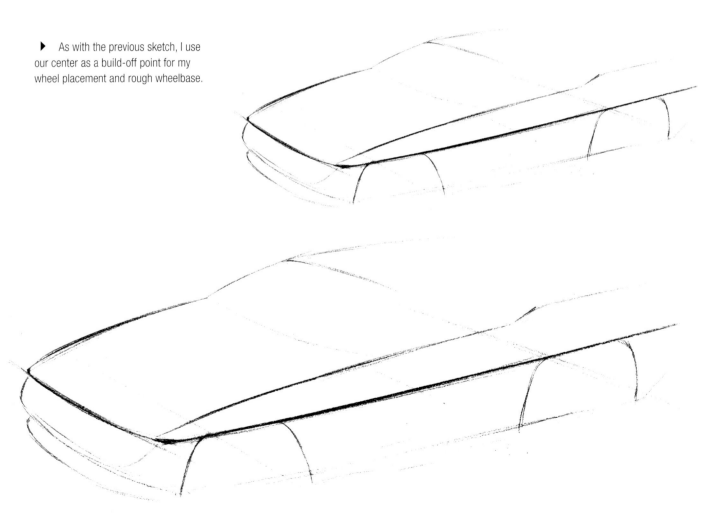

▲ With the wheelbase and front-end information down, I outline the silhouette, giving me a build-off point for the windshield, the bottom of the car, and the trunk, which was not visible in the previous sketch. At this stage, you can experiment with proportion and silhouette to give you anything from a truck to a race car.

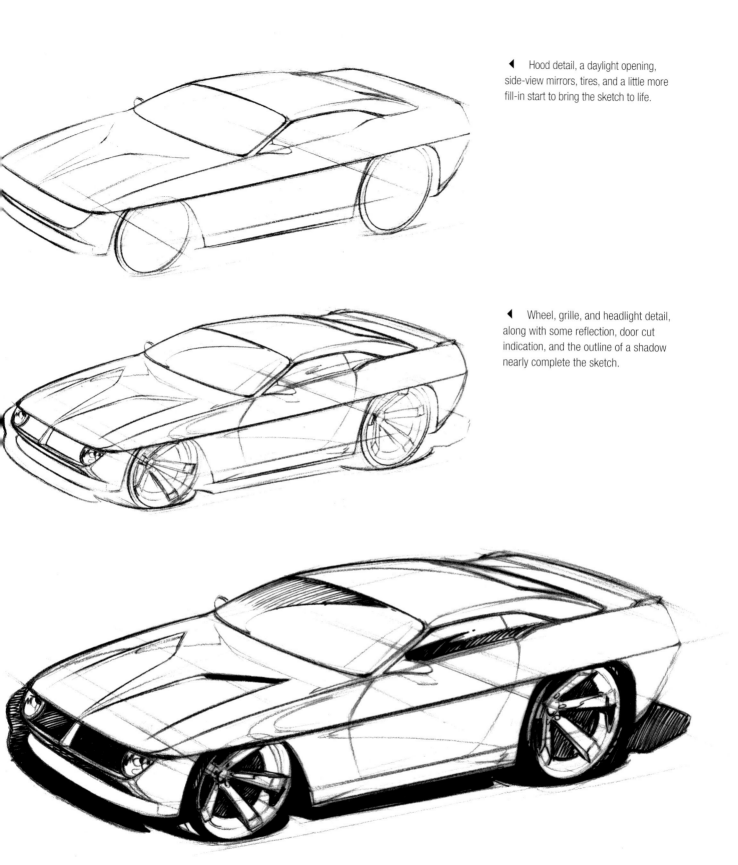

◀ Hood detail, a daylight opening, side-view mirrors, tires, and a little more fill-in start to bring the sketch to life.

◀ Wheel, grille, and headlight detail, along with some reflection, door cut indication, and the outline of a shadow nearly complete the sketch.

▲ This rough sketch can now be used as an underlay, or the guidelines and errant line work can be erased or cleaned up if you prefer a tighter sketch. This perspective is very descriptive for a car illustration.

▲ John Bell is a mad sketch artist whose work is scattered throughout this book. He puts steak and potatoes on the table by working for the computer game industry, but his many credits over the years include co–art director for *Jurassic Park*. This quick sketch shows his controlled line work, emphasis on certain areas of the car, and simple shading. Once it's popped into the computer some of the errant lines are eliminated and simple color is dropped in. Note how the car lightens up through the middle to help accentuate the length and sweeping side.

▲ A quickie pen sketch of a wild Formula coupe by Ed Newton. A lot of nice line quality is exhibited in the postcard-sized drawing. You can often read any number of seeds of inspiration from such simple sketches, which is why it's important to be able to transport these ideas from brain to paper. Once you get the concepts of perspective and proportion, as well as other basic skills, it's fun, easy, and a tool for you to sell your ideas—or just get you to the next good idea.

▲　Dave Bell is known for his varying line weights in pen and ink. When he wants to emphasize something or give a component substance, he uses heavier line weights. In the upper portion of this cartoon we can see how he starts: with very simple and consistent lines. Once he has the drawing sketched out, he comes back in and juices the lines up. As you will notice throughout this book, nothing is automatic—every sketch or rendering is thought out and built upon in stages.

▼　Steve Stanford's beautiful renderings start out with an underlay like the pencil sketch seen here. We can even see where some of the paint bled through to this underlay. The lines are simple and clear, without leaving anything up to the imagination that might box him in once he is well into the rendering portion of the finished piece.

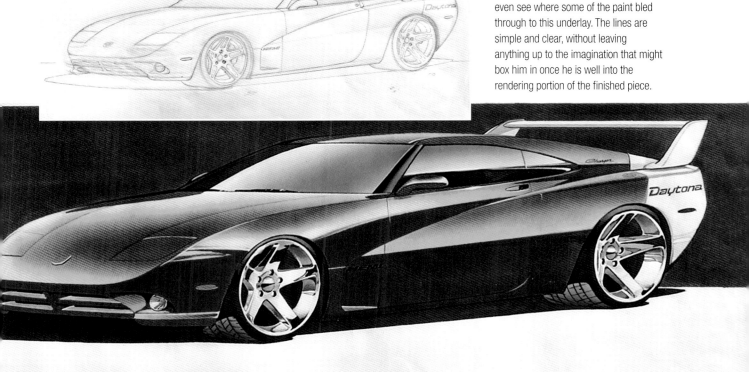

▲　These two drawings show two different sketching methods that Dave Deal has in his bag of tricks. The jeep is straightforward pen and ink—somewhat similar to the way Dave Bell does his cartoons. Crosshatching gives him differing values and gradations and acts like the stippling that Lance Sorchik uses in some of his cartoons (see Chapter Twelve). The Phaeton high boy sketch shows his black Prismacolor technique with just a tad of gray marker for the tires and undercarriage. Both techniques show a lot of action and varying line weights, and both look like they were a lot of fun to do.

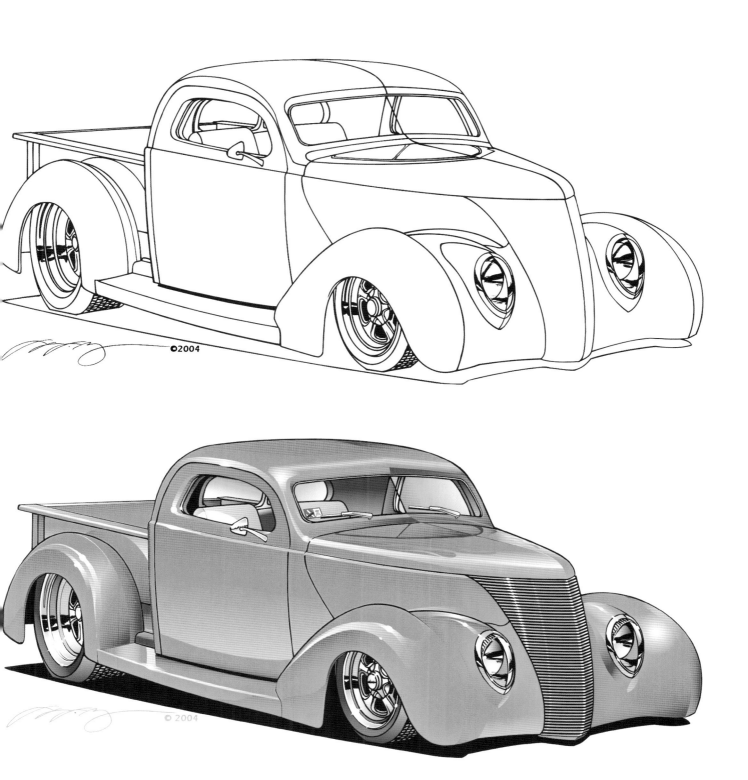

▲ In the last few years, Darrell Mayabb has switched his media from pencil to computer—all of his drawings are now created on the computer. By using a Wacom pad for the entire sketch, he gets very consistent and controlled lines, yet the stylus allows for emphasis and varying weights like a real pencil sketch. After the initial sketch, Darrell comes back and cleans it up before rendering it in with Photoshop. Even though a computer is used for the entire sketch, with Darrell at the controls it still looks like a Darrell Mayabb drawing.

Light Source

In Chapter Five, I told you we were done with the technical part of the drawing setup. I lied. Well, sort of. There is another aspect of the setup that could fall into the "technical" side of things: the light source within the drawing.

When dealing with shading, coloring, shadows, or even where to place certain line emphasis in a line drawing, the light source that is cast on your subject is very important. The light helps to define the shape of the subject, as well as where it is in perspective. And the color of the light source can add a whole new way to dramatically render your subject.

▶ In this drawing, the client wanted the Cadillac to look like it was painted in that flip/flop paint popular a few years ago, so I had to figure out the light source that would help this effect to read properly. The source was to the left, casting against the left front fender, the windshield, and the front portions of the wheel lips. The paint had to flop from blue to purple, but where the light hits it needed to glow with the gold pearl, so I was always conscious of where the light was coming form in order to make the paint read correctly. How did I do?

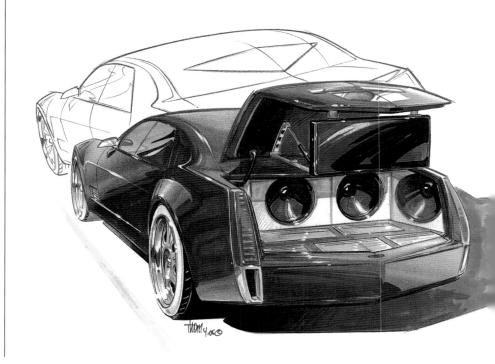

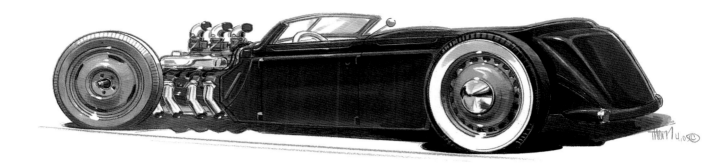

▲ Most cars that you render will have reflections because they are shiny, but in the case of this retro rod, I wanted it to look like it was painted a dark satin gray. You have to be aware of the light source because you want the highlight to "travel" across the surfaces you choose to highlight. In the case of this roadster, I also wanted to avoid too many hot spots that would make the paint appear shiny. I needed to cast shadows where I could to help hammer home the idea that this is not shiny paint—you can see this was done against the quarter panel behind the rear tire.

Generally, the lightest portion of the drawing is where the greatest amount of light is cast on the subject. The light values then get progressively darker as the surfaces move away from the core source of the light. Areas in shade are reserved for the darkest values. The easiest way to help you with this is to remember the one-, two-, and three-box theory. The top of the box is your lightest or No. 1 value. The side of the box closest to the light source is the No. 2 side, while the side receiving the least amount of light is the No. 3 or darkest side. This is one of those basic rules you must not forget.

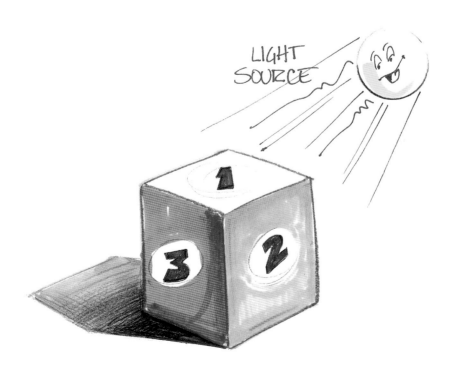

◀ For automotive drawing purposes, your light source—whether artificial or the sun—will create a one-, two-, and three-box condition. Remember it! It is one of the most basic rules by which to render, and another part of that imaginary space that you create on your paper. Here's a trick to help you separate the surfaces of your car. The top surface—in this case, the one closest to the light source—is the lightest, or No. 1 value. The next-closest surface to the light source is the No. 2 surface, which contains a medium value. Finally, the No. 3 surface, the one farthest from the light source, contains the darkest value. The shadow cast from the object can be considered a fourth value, as it can be an almost black.

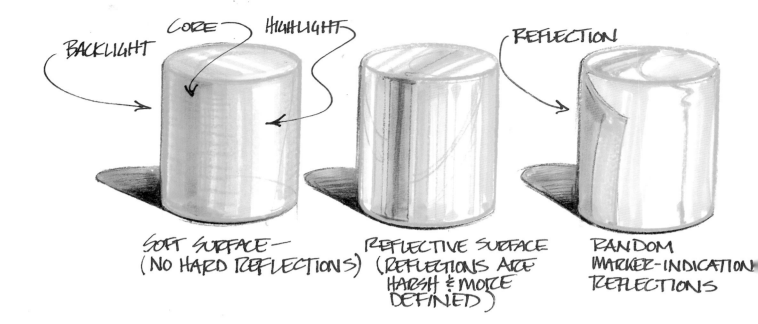

BACKLIGHT CORE HIGHLIGHT REFLECTION

SOFT SURFACE —
(NO HARD REFLECTIONS)

REFLECTIVE SURFACE
(REFLECTIONS ARE
HARSH & MORE
DEFINED)

RANDOM
MARKER-INDICATION
REFLECTIONS

▲ To see the effects of light on a simple object, look at what happens to these cylinders. The first cylinder contains soft surface indication by the use of a core and the lack of reflections. A small amount of backlighting helps to separate the back of the cylinder from the shadow. The second cylinder is the same, but with a reflective finish that creates harsher highlights and a few reflections. But, it follows the same general rule as the first cylinder. With the third cylinder, I added some random reflections to indicate objects reflected onto the cylinder.

Nature has given you a dark base from which to visually support your car by means of the dark shadow cast below it. A warning: Keep your light source in the general area of your head. Sure, it can cast from the right or left side of your subject, but not from behind. Lighting the subject from the rear eliminates the light and the concentrated values reflected as highlights on your car and only allows you to use a restricted range of values on the car's surfaces. In addition, it casts a big, ugly shadow of the silhouette of your car right in front of it, which can draw the viewer's eye to the shadow instead of the subject. You don't want the shadow to become the big bad hole into which the car is poised to fall.

To take the position of the lighting source one step further, try to have it cast on whatever side of the car it is most advantageous to define. In other words, if you are drawing a front 3/4 view of a car from the driver's side, you may want to have the light source cast more from the right side. This will allow you to cast it along the entire side of the car, yet still give you a bit of light to highlight portions of the front. Or you may prefer lighting from the left to give you the opportunity to cast light along the front, picking up all the highlights that grilles and air openings allow. You see, the light source is merely another tool you can use to help define the car. You control it for your drawing's greatest benefit.

Recall what I mentioned in Chapter Three about objects becoming lighter in value and possessing less detail as they move back into the imaginary space created in your drawing. This is somewhat contrary to the fact that as you move farther away from a light source, things get progressively darker. Yet if you observe mountain ranges stepped back, the mountains that are the closest appear darker and come forward from a visual sense. You may want to play with this phenomenon on paper to see what it does.

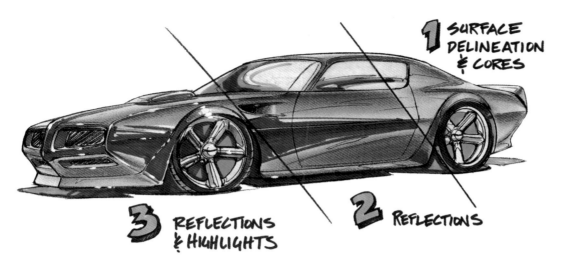

SURFACE DELINEATION & CORES

REFLECTIONS & HIGHLIGHTS

REFLECTIONS

▲ To take the cylinder examples one step further, this illustration shows that a rendered car is merely the combination of these three effects on its surface. As with the first cylinder, the surface delineation in area No. 1 gives us a basic surface foundation. Because a shiny surface acts as a mirror, it registers its surroundings as reflections. With the addition of highlights and some random reflections, the illustration is complete. For more on reflections, see Chapter Eight.

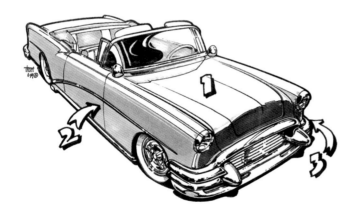

◀ The placement of the light source is up to you. However, placing it in the general area of your head, either to the right or left depending on which parts of the car you wish to highlight, puts the source in the best location for defining a car. Here, the light source is in the area of your left shoulder or left ear.

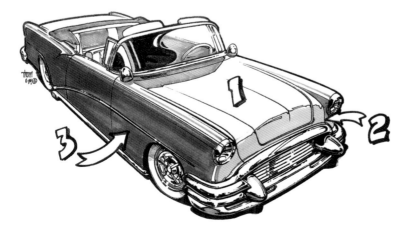

◀ We have reversed the location of the light source and placed it over your right shoulder or ear. This location gives you an opportunity to place a bunch of highlights in the grille detail and headlights. Doing this makes for a flashy sketch with all of the brightwork of this Buick emphasized.

▶ As a general rule, backlighting your car gives you little opportunity to separate and define the surfaces. It also gives you a nasty shadow in front while drawing attention away from your car—not good! Since no light source is hitting the surfaces you see, you have no opportunity to highlight those areas. However, once you have mastered the rules of light and shadow, you can break them.

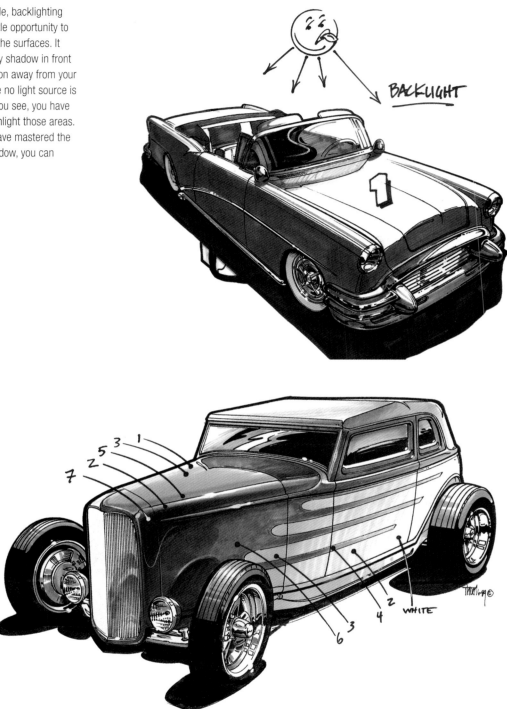

▲ As surfaces move away from you, they tend to get lighter in value. Emphasizing this, either with line work or by rendering surfaces, is known as "vignetting." Notice how the surfaces closest to you have the darkest values. I've given these values numbers to call out what is happening. Values range from a black value of No. 10 to No. 1, which is white. With the exception of the white highlight in the hood and the subtle front tire reflection in the hood side, this car is rendered as a dull or soft surface.

◀ Now when you look at car art I hope you look for the staging within the scene. In the case of this Ed Golden scene, the light source is intense and low and to the right, backlighting the Funny Car. Notice how the windshield and rear spoiler really light up—they are the surfaces most directly facing that imaginary light source. As an aside, note the close range of colors that he's using. Though exaggerated, with a setting sun, objects get a warm cast that obliterates some of the more muted details.

▼ John Bell's kooky hot rod from the year 2525 is lit from both the back and front. The backlighting from the explosive exhaust almost obliterates the back of the car and would probably overshadow the rest of it, too. But John wanted the viewer to be able to see the car, so he included some light coming from the vantage point of the viewer. Also note that in his original sketch he intended for there to be a shadow directly below the hot rod, but with such intense light from the exhaust, this probably would be an incorrect indication, which he must have figured out in the final color rendering.

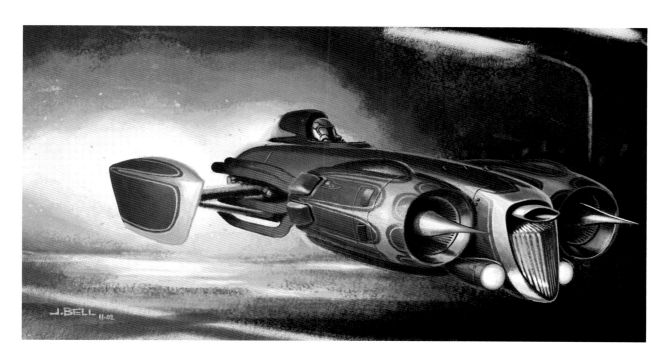

▲ The sense of the fenders sticking out on this side sketch by Danny Ellis is enhanced by the highlights that make them seem like they are reaching out to catch the overhead lighting. For consistency's sake, Dan also ran those highlights along the top and the body seams, which would pick up little glints of light from overhead. Always make sure you are consistent with your light indications so that the car reads properly and doesn't confuse the viewer.

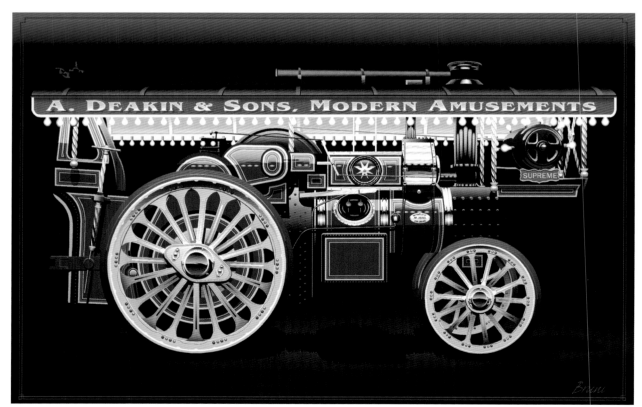

▲ This is a showman's locomotive used in the first half of the twentieth century in England to haul amusement machines to fairs. This particular example survived the scrap drives of World War II and was restored in the 1970s. This is one complicated vehicle when it comes to determining how to handle light and reflection. With so much going on—the lights, graphics, components, and more—by trying to be literal, you could easily end up with a poodle in a microwave after the explosion. Jim Bruni took the "less is more" approach by limiting his reflections and highlights, and instead letting the beauty and complexity show through. Sometimes it's harder to leave things off of your drawing than it is to draw things into it.

◀ Though unusual for an outdoor car scene, the light source in this Dave Deal painting is a single source that casts light radially, unlike natural light, which is parallel. If this were a day scene, the source would be from above and cast as in most of the setups we have seen. With this setup, your eye is drawn right into the middle of the scene—which is where the advertiser's logo is placed.

◀ Another Ed Golden computer sketch, this time with artificial light coming from two sources—the header flames. In this setup you need to concern yourself with two sources that must consistently cast throughout the car to read properly. Looking through the windshield, you can see how the driver's side windows are lit up and how the ground picks up the light on both sides of the car. Once you get the hang of lighting under normal circumstances, it's fun to play around with setups like this.

Shadows and Reflections

Rendering reflections on the shiny surface of one of my sketches is probably the most enjoyable part of doing the sketch. Knowing how to do it properly takes a certain amount of practice, along with constantly observing exactly what happens to a car's surfaces in the real world. When dealing with reflections on a shiny surface, you must remember that your reflections should not look like stripes painted on the side, but they should look like, well, like reflections. Before you start to render-in your reflections, a good way to look at the task at hand is to keep in mind that the car's surfaces are really just one huge mirror that reflects back what is around it. Carefully observe the surface, visualize what is reflected from it, and you have the basis for your reflection patterns.

Although I show some step-by-step examples in this chapter, there are a few ways you can become equipped to sketch reflections into any surface you choose. The first and best way is to observe. It may be an obvious thing to suggest, but a car's surface changes continually. It's always good to observe the reflections dancing over a surface to see how they react to changes in direction, indentations, and sculpturing. Keep a sketch pad with you and draw what you see as reference

▶ You don't have to go nuts with reflections. This simple sketch utilizes reflections in the chrome, but only in simple patterns. For the body, the black stops right where the surface turns up toward the bright sky. Here, simple highlights are also kept to a bare minimum, being picked up from directly above the coupe. This approach makes for a very clean black-and-white sketch.

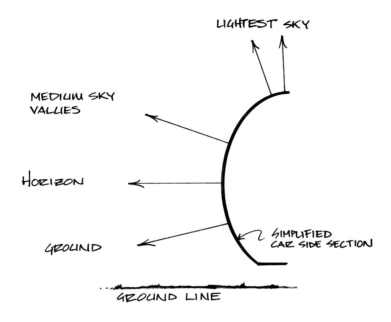

LIGHTEST SKY

MEDIUM SKY VALUES

HORIZON

GROUND

SIMPLIFIED CAR SIDE SECTION

GROUND LINE

Think of a car as a giant, slightly convoluted mirror that reflects everything around it. This becomes another element of the space you create when you draw a car. Where is it? What is sitting around it? Where is the light source? You set the stage for your car drawing, and you create that stage to best define your car.

for future use. A good selection of reference material freezes in time the way a particular surface change reacts to what is around it.

Combine your observations and reference material, try a simple thumbnail sketch on scratch paper until you are satisfied with what you see, and then apply it to your sketch. The use of a thumbnail sketch is great for several other situations: helping with proportions, placement on the page, backgrounds, and color

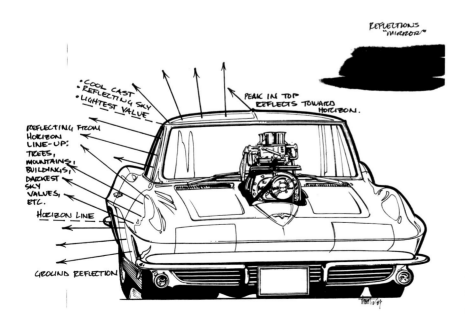

REFLECTIONS "MIRROR"

• COOL CAST
• REFLECTING SKY
• LIGHTEST VALUE

PEAK IN TOP REFLECTS TOWARD HORIZON.

REFLECTING FROM HORIZON LINE-UP: TREES, MOUNTAINS, BUILDINGS, DARKEST SKY VALUES, ETC.

HORIZON LINE

GROUND REFLECTION

Defining the previous point further, this radical 1963 'Vette has surface changes that pick up conditions within its environment from all different directions. Not only does it pick up reflections, it picks up cast colors like cool shades from the sky, warm colors from the ground, and highlights from the compression of the light source at surface changes.

So, what is reflected onto your car? All of what is shown here and more. Anything you wish to reflect is fair game—just make sure you don't confuse the viewer, or your car will end up looking like the dinner in Fluffy's cat bowl. Most of the examples in this book tend to simplify the scene. A car's body will usually compress and stretch out reflections so that the horizon becomes merely a thin, dark area reflected onto the side of the car.

selections, to name a few. Don't be embarrassed by the need for a thumbnail sketch. I've seen some of the best in the business make a thumbnail sketch for almost every rendering or painting they do.

Another aid is to have a scale model or toy at your desk that can be used to stage certain reflection problems before you begin your sketch. Though the model won't provide exact solutions to your particular car's design (unless it is a model of the car you are sketching), it will help in showing how objects close to the car will reflect on its surfaces, or how its windshield will reflect into the hood. Be careful though, because a model sitting on your drafting table will not mimic a car's real environment.

You will want to show your subject in the best way, by placing it in the perfect environment. This may mean you will actually be creating a setting that is almost unreal. If your car has a unique feature that you want to show to its best effect, you may render the car in a special way to highlight this feature. It may mean running a reflection through that portion of the car to help it pop out or lighting the car in such a way that it draws the eye to this area, or bringing it out with color by adding a warmer tone through it.

Usually, you will not want to copy the reflection detail-for-detail, but rather you will stylize your reflections to keep them simple. You don't want your reflections to overpower that sketch; they should blend in and enhance the subject. Fussy, involved reflections may show your ability to copy what happens in the real world, but they don't make for a flashy, punchy drawing. Keep your reflections clean, and your sketch will be, too.

Many of the suggestions that apply to reflections apply to shadows as well. You don't want them to overpower the sketch or look like they were pasted onto the surface of the car. Like reflections, shadows will need to follow contours and surface changes. As for ground shadows, they will need to be plotted properly so that they help define the bottom of the car, including its tires. This will give it a foundation off which the car can play.

I like to do the ground shadow in solid black. But in doing so, there is always the risk of giving the impression that the car is floating over a big black hole, ready to fall in at any second. This becomes an extension of what we learned in Chapter Seven concerning light sources. Defining the tire's shadow and where the shadow cuts in to separate the wheelwells from the rockers or running boards gives detail and breaks up the shadow's edge. And in doing so, it helps avoid the dreaded black-hole syndrome.

A gradually curved surface will pick up the "perfect" sky, horizon, and ground setup like this. But we usually aren't reflecting a perfect world—normally, a lot of objects and obstacles get in the way. Still, this perfect setting makes for a more believable scene reflecting into your car.

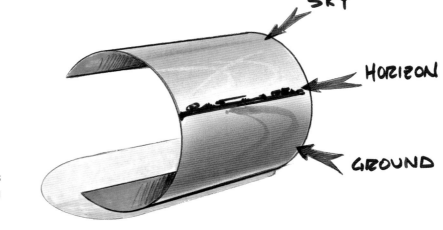

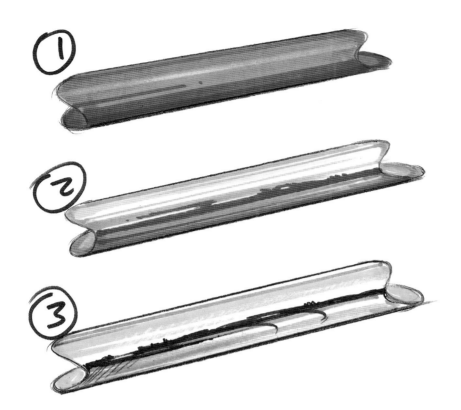

◀ No. 1 represents a simplified example of what would be reflected onto a slightly dulled or less-reflective finish. No. 2 takes that same tube, in the same color, and gives us a sample of a much more highly reflective finish. The reflections now have more contrast, and the horizon is slightly more detailed. No. 3 represents a chromed finish. Chrome is much more like a mirror—there is no color tint, so the reflected colors appear much like they really are. Since our drawings will tend to be done on paper slightly larger than this page, such reflections will be a few simple indicated lines.

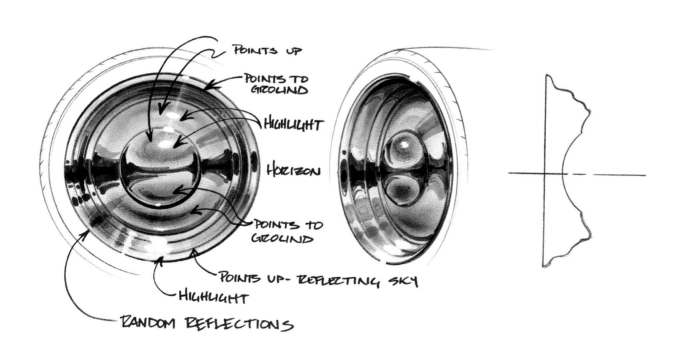

▲ That which reflects on the side of your car's body also reflects on its wheels, bumpers, windows . . . everything! This illustration shows the environment that is reflected back into the wheel. And since chrome is colorless, the reflection is much more like a mirror.

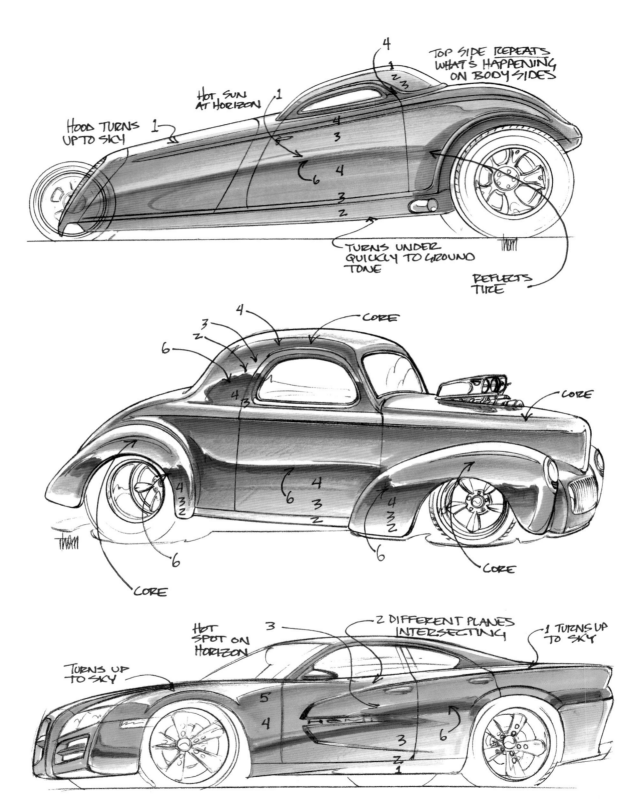

To further illustrate reflections in cars, here we have three different vehicle side views, all reflecting the same environment. The numbers across the bodies indicate values, with No. 1 being white and No. 10 being black. Note that below the harsh turn-under in the coupe's side, the surface picks up ground indication only. There are all kinds of variations on these examples, but these are a foundation for every car drawing that includes reflections.

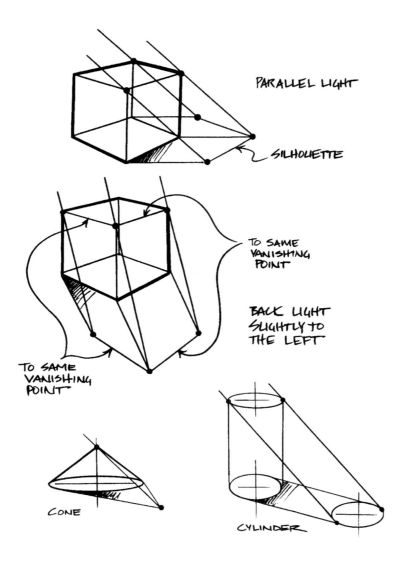

PARALLEL LIGHT

SILHOUETTE

TO SAME VANISHING POINT

BACK LIGHT SLIGHTLY TO THE LEFT

TO SAME VANISHING POINT

CONE

CYLINDER

There are some fairly standard rules to follow in order to give a proper shadow indication. These simple objects give a general idea of how shadows are created. Since cars exist outside, during the daytime, at least, the light source will always be the sun. Because it is so far out in the distance, the sun's rays are not radiating but rather are essentially parallel, which makes for easier plotting. A shadow is created when the outermost surfaces or edges that catch the sun's light are cast against another surface, usually the ground.

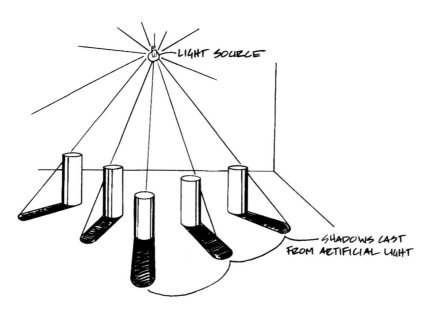

LIGHT SOURCE

SHADOWS CAST FROM ARTIFICIAL LIGHT

Although we will be dealing with natural sunlight, this is the effect of artificial light on an object. Unlike the sun, the light rays are radial instead of parallel.

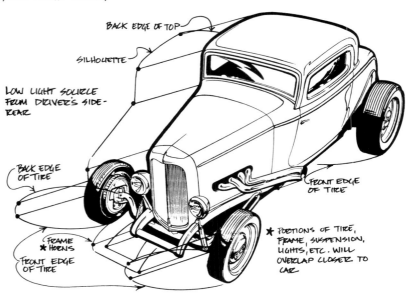

▶ Since shadows can be a bit complicated, and mechanical means of plotting are too time-consuming, we draw them by observation. However, this exaggerated example shows how one might go about determining where to place shadows. Where possible, I have indicated changing surfaces or corners with a dot. Notice how each tire casts an almost perfect ellipse whose major axis is parallel to the light source. Study this drawing to get a basis for determining the shadow problems in your own setup.

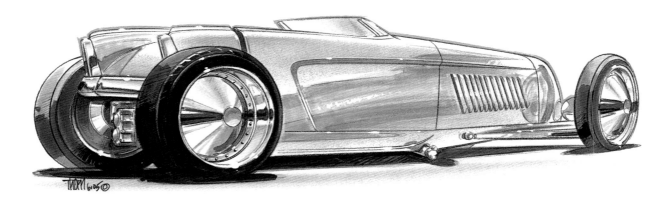

▲ When rendering a silver color on a car you have to be aware of several things. Just bonking in some gray will only make the car look gray. To make it read that rich silver look, you need to dust in some blue on the top surfaces to indicate sky reflections and a brown/pink/beige type of color on the lower surfaces to indicate ground reflections. BUT, you don't want to overdo it because it can give the effect of being polished aluminum or chrome. You'll need to experiment to see how much or how little blue and brown it takes for silver to be silver.

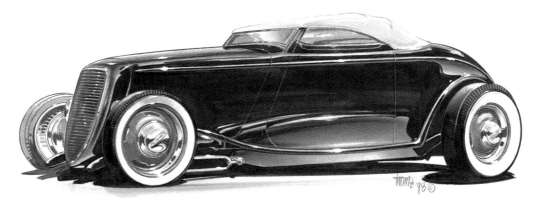

▲ Here's a hot rod rendered in black utilizing the necessary colors to achieve that black look. It's a similar situation to the previous silver example in that you need to dust in blue for top surfaces and browns for lower reflections. The difference is that the blues and browns must go very dark at their core—black, really. Why? Because a black car is just a mirror of what is around it—except that the reflections need to be darkened up. Look at cars in real life to see for yourself.

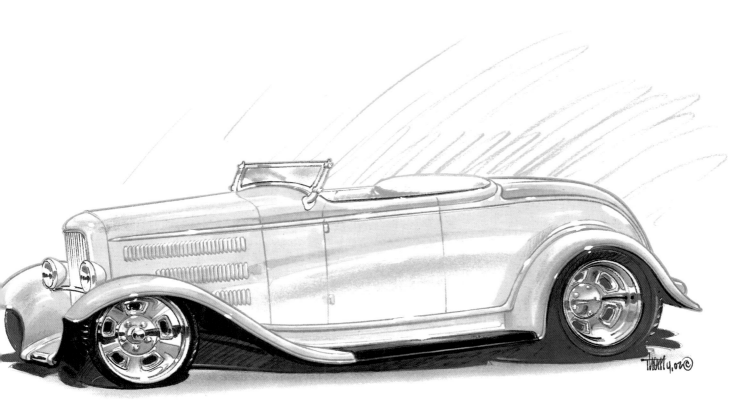

▲ Guitar-slinger Eric Clapton wanted to see his '32 roadster project as it would look in his favorite color: baby blue. That's great, but you have to watch out for something: When rendering light-colored cars, you have to be careful that they have a solid look and feel when you're all done. In some renderings I've seen, the artist was too timid with the reflections and color saturation, and they look like they are made out of colored glass—not good! Cars are painted metal and they need to look that way. So even though the temptation is to use a light hand when rendering in your light-colored car, you still have to hammer the color in. To add interest to this drawing, I ran some purple into the shadows because the rendering would look too plain using just black, blue, and white.

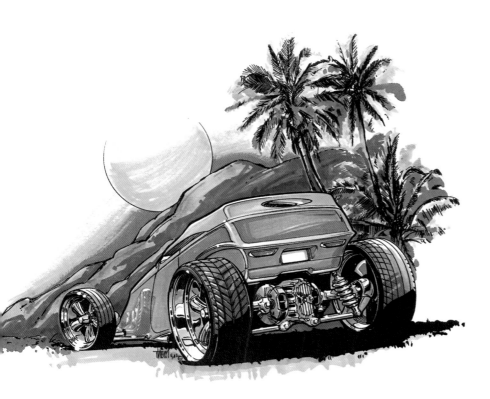

◀ If you look closely, you'll notice that the back surface of the front tire and wheel are reflected back in the hood side. You must always be aware of what components attached to the car will reflect back into the car—things such as side-view mirrors, tires sticking out away from the body, hood ornaments, and so on. They may also cast a shadow on the body, so in the case of side-view mirrors there are two situations to address.

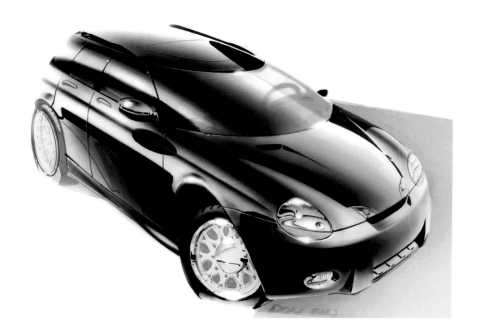

If you're trying to sell a design, you need to highlight certain aspects of it, and there is no better way to do it than with reflections. Danny Ellis does this to a T. His black reflections call out certain aspects of the design to help delineate the surfaces. In this case, he also used the cast shadow as a graphic design element. This is what I would call a classic Art Center College of Design rendering.

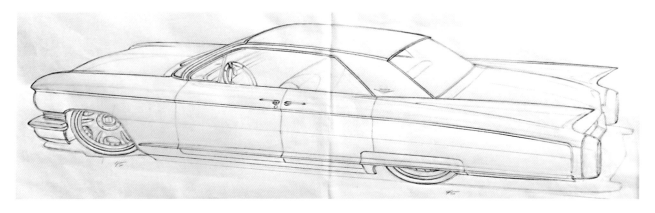

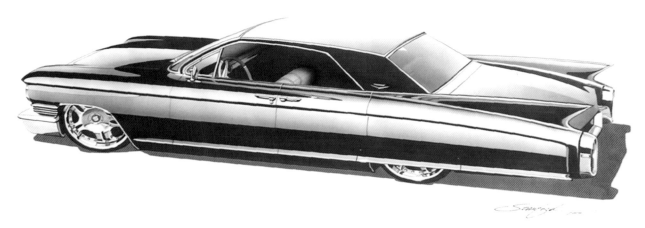

▲ To me, Steve Stanford is the king of the understated reflection. He keeps them real low-key, simple, and direct. This is no more evident than in this '62 Brougham rendering. (Cadillac never made a Brougham in 1962—it's just Steve's fantasy.) In many ways, the simple reflections mimic the classic Cadillac depictions from these same years. Steve even keeps the reflections so simple as to show the rather bright red shadow only reflected into the lower portions of the front and rear bumpers. Very cool!

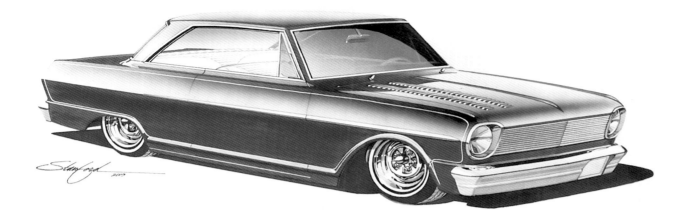

▲ Another example of Steve Stanford's low-key reflections. The blue reads very blue—almost candy blue. It really doesn't need to have wild reflections interrupting the simple sides of this Nova. In some cases candy, pearl, and metallic paint jobs tend to knock back reflections that would otherwise stand out on a solid paint job. In a lot of cases, the gradation starts at the edge of the reflection instead of away from that edge. It's a subtle way of indicating a pearl or metallic paint job.

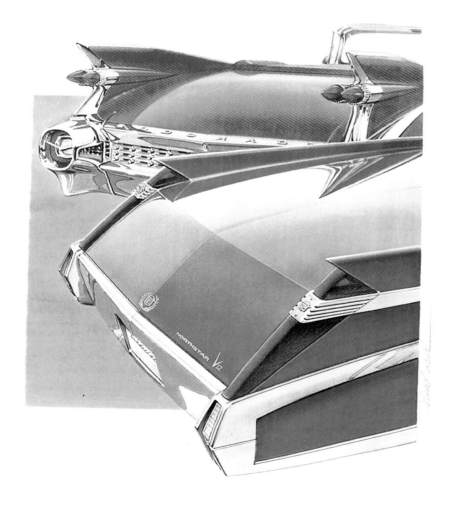

◀ Steve Stanford has told me that he likes to keep his chrome indication very simple without the myriad reflections you might see in some people's work . . . mine, for instance. He applies that "less is more" theory with his paint reflections, too. Notice that the fin of the '59 is reflected into the trunk of the concept Cadillac, as is its own fin. Also note that the pink background has been bounced up into the bumpers of the two cars that are sitting on it. It ties them together and gives a reason for the background to be there in the first place.

▲ To finish the point, here is another Stanford rendering exhibiting simple reflection patterns. It basically mimics an uninterrupted plane or landscape reflected back into the Porsche. Because the side windows start back up in about the same plane as the body, beginning at the beltline they pick up the simple landscape again. If the curve in the side of the body were continuous all the way up to the top, this would not happen. Note that the body also picks up a bit of its own shadow and the side of the bumper in the inset below the deck lid.

▲ The presentation on this Jim Bruni rendering is great, but we are going to hone in on the colors behind the incredible Frank Lockhart Black Hawk from 1928. Look closely and you'll see the orange background reflected into the top surfaces of the car and the maroon background behind the lower portions of the car reflected into the bottom surfaces. This really helps to define the shape of the silver body which would otherwise be hard to do in a side view. This reflection makes the background more than a background.

▲ One of my pet peeves is art with graphics running through the body surfaces that do not carry the reflection of the body through the graphics as well. If there are reflections anywhere on the body, and a decal or racing stripe or whatever is within the location of that reflection, it too will have a reflection running through it. See the reflections running throughout the body in this Jim Bruni illustration of a Gulf 917 Porsche.

◀ Here's a cool business card that Darrell Mayabb made up depicting a simple Deuce high boy with the only reflection seen in the trunk lid coming from the tire. There are no side reflections, yet the coupe reads well. Also note that the shadow is directly below the coupe, so essentially he's placed the silhouette as a shadow. It is easy and it works.

◀ I've said it before—once you have a handle on certain aspects of drawing cars, it's fun to experiment. Ed Newton's Pharod is such a case. Though rendered on black board, the Corvette takes on an eerie effect with the purple glow radiating from the ground. And the harsh orange lighting from above provides a nice contrasting color to play up both opposing colors. With just a little gray and white thrown in, this relatively limited use of color becomes quite dramatic. It's not a true depiction, but it looks like it could be real—see the difference?

▶ Using a dark shadow on a black background just doesn't work. One way to get it to show is to cast a subtle light around your car, as Ed Newton has done in this rendering. The light adds interest to the ground and allows you to bounce a little of it back into the rockers of the car. Mainly, though, it lets you separate the shadow out from the ground so that your car looks planted instead of floating.

▶ Sometimes just a hint of reflection is all that you need, as in the case of these Baja racers done by Dave "Big" Deal. The only apparent reflections are in the top surfaces of the racers—specifically in the top of the orange one and in the hood of the yellow one, reflecting the "thumbs up" from the driver. And look at the shadows. Without even thinking about it, you know that these guys are barreling through the desert because the shadows indicate that the right-side tires on each racer are up in the air. This would add action even if there weren't speed lines coming off of the racers.

◀ I used a rough underlay to trace this out. Since we aren't dealing with perspective, the rough can be fairly rough, but at this stage I still want the sketch to have as much detail as possible so that I'm not guessing once I'm into the final product.

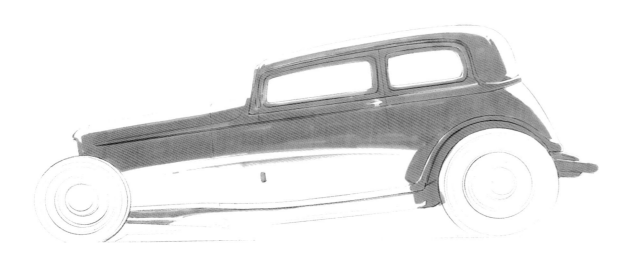

▲ The major reflections are blocked in at this stage with color marker. This is a reflection of a rather thick horizon to the extent that it takes up the upper portion of the body. I do this to keep the reflections in the window area as simple as possible; there is a lot of detail that would get obscured if I got into complicated reflections.

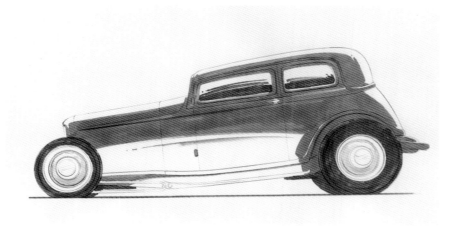

◀ I want to have a tint of red in the shadows and tires to add interest, so I block in the red. You may choose to go with gray to keep this more realistic. I also want to carry some of the red into the car so I include it in the side windows as well. And since I'm adding color, I block in the cream portion of the painted steel wheels at this stage too.

71

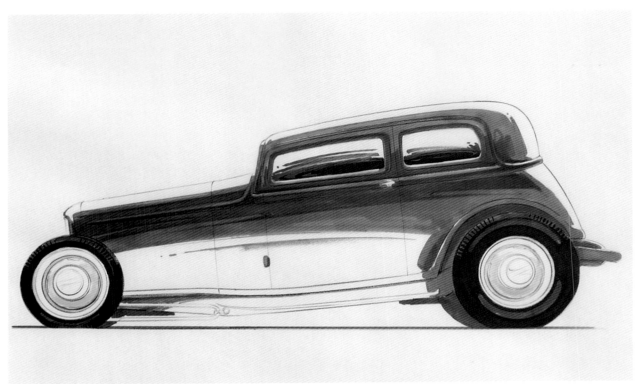

▲ Black marker is used in the more traditional portions of the tires and shadows. We'll blend the black into the red later. For the moment, I leave pure red those surfaces that would pick up the most light. I also add black in the side windows to help them contrast with the lighter portions of the reflections we'll run in them later. Finally, I include a secondary reflection of slightly darker value within the main reflection to add a bit of interest. It indicates something darker than the general reflection picked up in the body—maybe a dark hedge or a dark, painted section of a building. As long as you are aware of how things are reflected you can justify almost anything. Just be careful it doesn't end up looking like a giant pizza draped over the car!

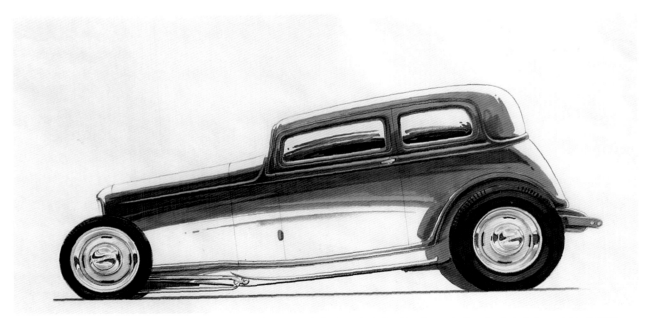

▲ I try to finish more of the rendering before we get to the messy chalk stage, including the chrome in the wheels, hairpin, and door handle. There's not much chrome to these early hot rods. I also start to blend the black into the red tires with a No. 5 gray marker. You may also do this with a black pencil or black chalk. There's no right or wrong way.

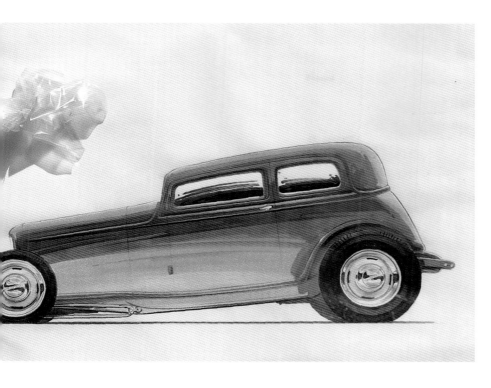

◀ You need to mask off the outside portions of your drawing when it comes time to sling some chalk. Use drafting tape (not masking tape!) or frisket film cut out with an X-ACTO knife. I use frisket and here have shown the wad I pulled off of the area we'll be chalking up. I ran the warm brown up against the areas of the body where I stopped the marker reflections. (Because this is a simulated metallic paint job the chalk will flow with the gradation instead of puddling in the area between the reflection and the edges of the car body.) Then, carefully blend with either a cotton pad or, as in my case, with my fingers, creating a gradation. If you load up with too much chalk, you can erase or wipe some of it away with a paper towel.

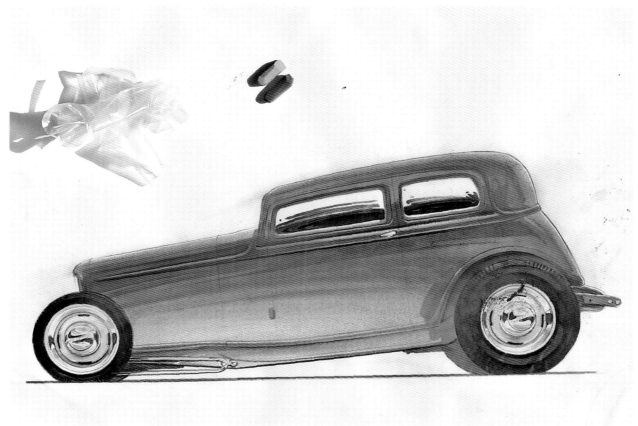

▲ To richen the color, I come back in with a darker value of chalk. You will need a good range of markers, colored pencils, and chalks to do these subtle things. Because this is metallic paint, the difference between the reflection and gradation surrounding it is softened a bit more than if it were an indication of a solid-color paint job.

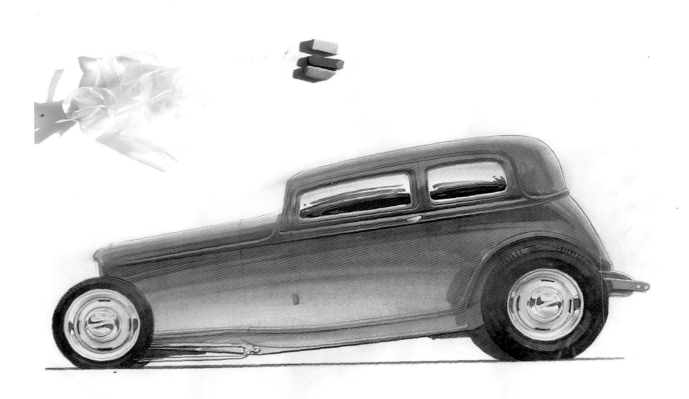

▲ Since this is masked off, I thought I would complete the chalk phase by putting the sky-tone reflections in the windows. I let the color fade a bit as it comes to the B-pillar to indicate a slight bit of body wrap.

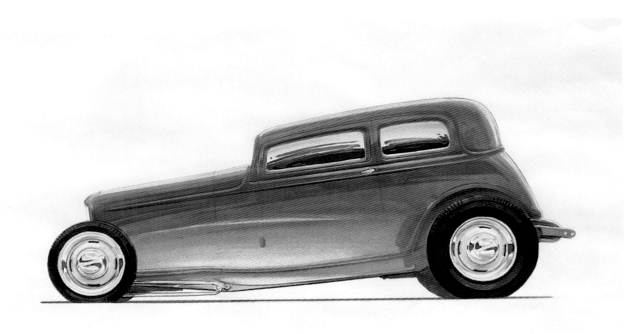

▲ After washing my hands of the dreaded colored chalk, I blow a bit of fixative over the drawing to lock in the chalk. Once it's dry, we can start working on it again. At this stage, I finesse the chalk by cleaning up the gradations, reflections, and/or highlights, either with my hand, a paper towel, or a sharp-edged eraser. I try to exaggerate the dark to light as much as possible without making it look odd. You'll know it when you see it.

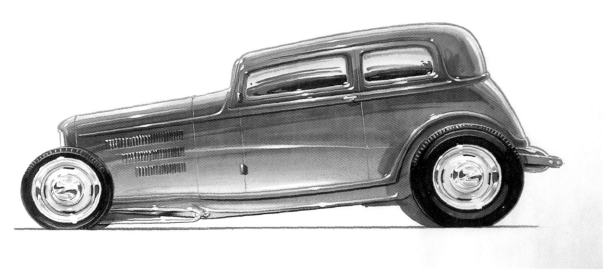

▲ This is as good a time as any to add the louvers. Since they are placed right on the surface of the hood, I usually wait until last because the reflections and/or gradations aren't really affected by them. If it were a hood scoop or something more prominent, I would tie the reflections into them. You'll see examples of this throughout the book. Highlights are drawn in with a white pencil, and a No. 0 or No. 1 Windsor Newton brush is loaded with white gouache and the pigeon highlights added at the hot spots, usually in line with the light source. I also add a bit of highlighting to the tires and finish it off with a purple outline for contrast, thereby subtly intensifying the copper color and framing the car. We're done with the actual rendering of our 1932 Ford Victoria.

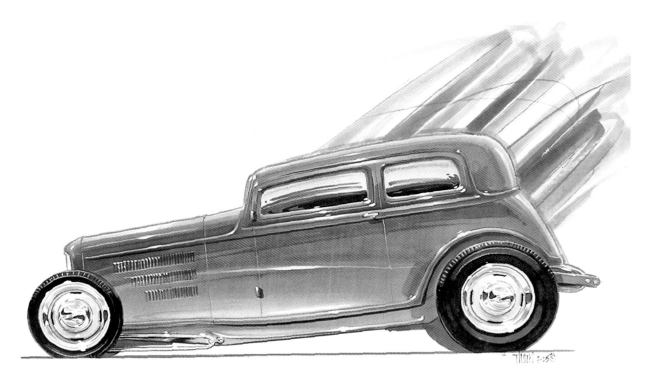

▲ The final step is to throw in a marker background to help punch the drawing off of the page. Make sure that some of the paper shows through so that the background stays light and airy, not intense and distracting. Sometimes I mask off the car with drafting tape before creating the background so that I can be a little loose and make the background appear more random and arbitrary. You may calculate how it will look, but you still want it to look arbitrary. Sign it, date it, and go relax on the couch—you've done a good job!

Technique

▼ This is a fairly typical example of my technique: marker, chalk, a little colored pencil, and a dab or two of white gouache for highlights. That's it! Over the years, I've bastardized this technique from the way we were taught to do marker sketches in school and tailored it to work in magazines and for presentations.

Technique means the way you actually draw, as well as the medium or utensil used to achieve the drawing. Everyone has a technique lurking inside them. Your technique is your unique combination of seeing things, your dexterity, a heavy or light touch, ability, experience, and even how you feel on a particular day. These, blended with more mechanical circumstances, such as what type of pencil or marker you are using, the type of paper you have, and whether you choose to draw in color or black and white, make for the characteristics that define your technique.

Just because you cannot do a drawing exactly like some examples shown in this book does not mean you aren't drawing properly. It just may be your technique starting to show itself. That's great! The difference is what makes your own efforts prized and marketable, instead of just copies of someone else's work.

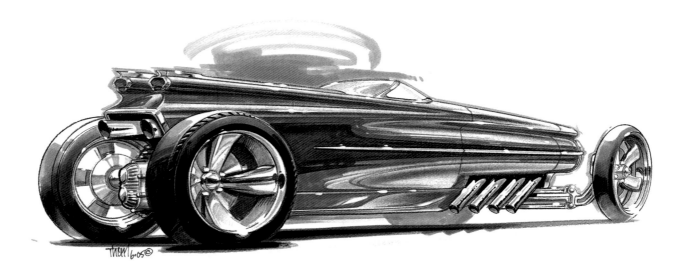

I've gathered the works of some top automotive designers and artists to illustrate the great diversity in techniques that are possible. Even when similar materials are used for some of the drawings, scrutinize how the differences come through. This is one reason someone wants an Ed Newton sketch instead of a Thom Taylor, or why someone would prefer a cartoon from Dave Bell instead of Lance Sorchik. It's technique—the unique way one draws—that attracts a following or creates interest in that particular person's work.

I've also included examples of different techniques applied to an identical subject. This can be a lot of fun to try and it gives you experience with different media, techniques, and papers. You may find that the same sketch is easier or more rewarding when done one way rather than another. While you may discover that you prefer the work of a particular artist, strive for your own technique. Hopefully, along the way you'll achieve a style that is uniquely yours.

▲ Here's another typical example of how I do my sketches. I try to run a little bit of color into the tires and shadows to add interest while keeping the reflections bold and random-looking, even if they're not. In a case such as this, where the framing wood is so finely grained, I render it in as solid, adding grain only to the dark mahogany inserts because they tend to have clusters of wavy grain. As objects move away from the center of the car, I try and fade or vignette them out as I have done with the far front and rear tires.

◄ Here's another technique I use where the drawing is done in fine-tip marker and the color is plugged in with colored markers. In this case, I was doing art for Reyn-Spooner, the Hawaiian shirt people. They needed a guide for their fabric printers in Japan, and this was an easy way for them to see what I wanted. Because they use solid colors without blends, I tried to duplicate that look with this art.

▶ Dan Ellis has been an automotive designer for over 25 years. This is an example of one of his quick computer sketches. His technique is similar to other artists in that he scans in a pencil sketch and then blows in the color in layers with Photoshop—but it is still uniquely Danny's sketch. He's even plugged in an actual scanned tire/wheel up front to speed things along. Also, notice how he brings the background into the back surfaces of the car. Because the background is a cold color, it also helps to push the back of the car back in the drawing.

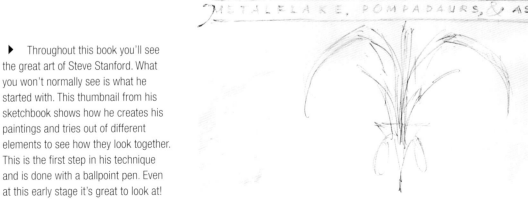

▶ Throughout this book you'll see the great art of Steve Stanford. What you won't normally see is what he started with. This thumbnail from his sketchbook shows how he creates his paintings and tries out of different elements to see how they look together. This is the first step in his technique and is done with a ballpoint pen. Even at this early stage it's great to look at!

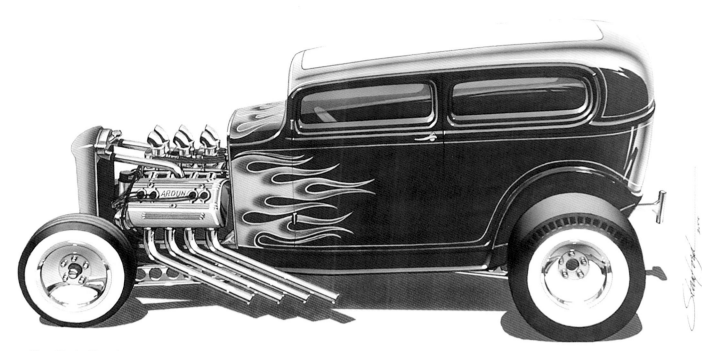

▲ Steve Stanford is self-taught, which is cool because he sometimes does things a little differently from the rest of the pack, many times with exceptional results. For instance, he uses animation cell paint sprayed through an airbrush to get the nice gradations in his work. Sometimes even the solid areas are achieved with sprayed-on cell paint. First, he draws his image in pencil, then he starts noodling away with a colored pen, pencil, or the cell paint brushed or sprayed on. His renderings are always nice and clean.

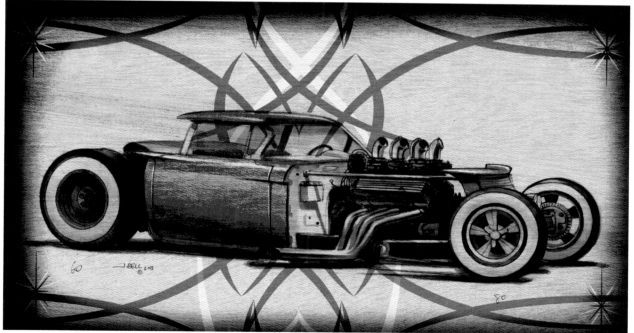

▲ John Bell is adept at drawing cars, creatures, and cartoons, and he has worked in the movie and game industries for years. But to wind down in the evenings he likes to do these simple paintings on wood. It's entirely different from the computer-generated art he does during the day, which is why he likes to do it. This technique involves sketching the art out in pencil, transferring it to the wood, and painting it with acrylics—or sometimes whatever he has lying around. And they are fairly quick, too. He's actually wanted to build this crazy hot rod, based on the body of a '59 El Camino, for years. It's nutty and typical John Bell. There's more at www.johnbellstudio.com.

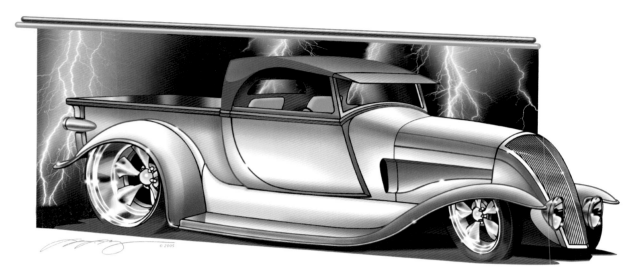

▲ Just the opposite of John Bell, Darrell Mayabb was driven to mess around with the computer for the unique break it gave him from traditional media, which he had mastered over the years. It's a new and fun tool, and Darrell has embraced it to such an extent that he now does all of his sketching and rendering on his computer, yet his art is unmistakably of his own style. This roadster pickup has that Mayabb look, with its exaggerated wheels and tires and simple shading.

▶ Here's another truck by Darrell Mayabb done in Photoshop. He keeps the colors within a particular range—even using the color of the truck for the background. Darrell has a distinct technique that comes through in all of his work. You can see more on his Web site, www.automotivegraffiti.com.

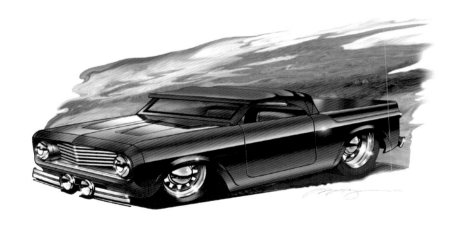

▶ Ed Newton likes to play around with different techniques. Here, he used gouache on black board to see if he could apply the least amount of pigment and still achieve a fairly finished rendering.

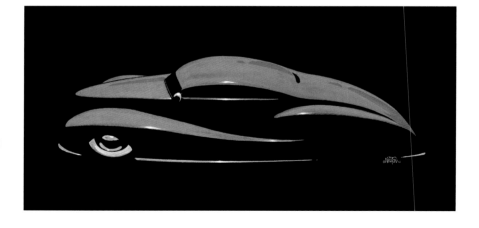

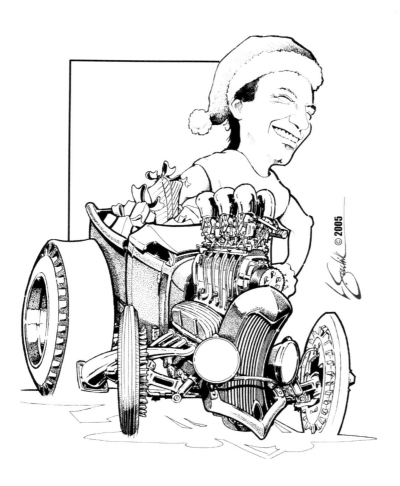

Stippling is a process where the artist uses small dots of paint or ink to create a blend or gradation. Though most of Lance Sorchik's work today is done in Photoshop, in his earlier days he used stippling, as seen in this roadster pickup—it was his technique and helped to distinguish his pen and ink sketches. It's also interesting that here he leaves the tire and shadows white as opposed to blackening them in. It is yet another unique trait of Lance's.

Lance Sorchik uses stippling to indicate the softer gradation that primer paint gives off. For the harsher reflections and gradations of chrome, he uses crosshatching, which helps to distinguish the different finishes found on different components. Different finish, different way to depict the finish—they are tricks that Lance knows well.

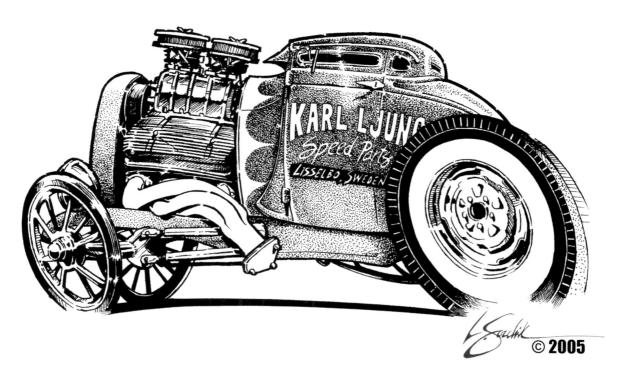

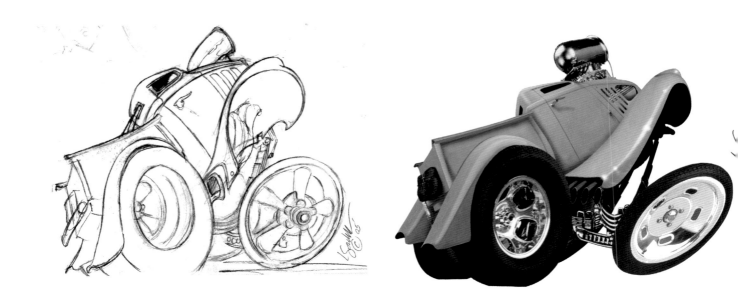

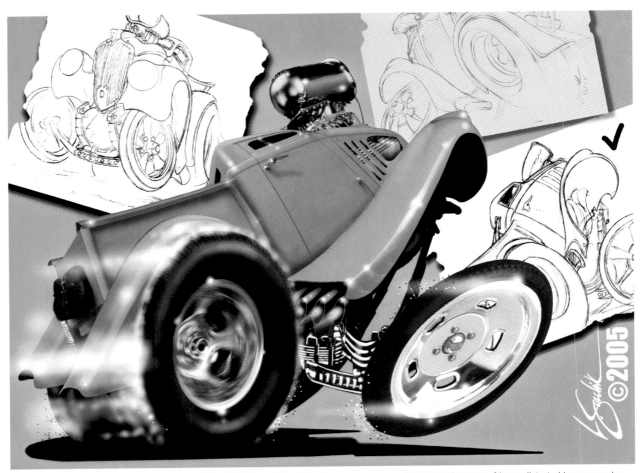

▲ This is Lance Sorchik playing around with his Macintosh. The photo he uses is separated and the elements of it are distorted in a way only Lance can do. His unique way of doing art transcends the medium he happens to be using at the time. Of course, because he has to figure out what he's going to do with the photo "pieces" once he starts to create the art, he still utilizes a pencil sketch (which we have included here) as a guide and can also be seen in the background of the final rendering.

Charlie Smith has spent years mastering the Painter program. Still, he must sketch the car in pencil before scanning it into the computer and letting the pixels fly. He knows every detail of his car before he enters it into the cyber world. These before and after images of a future Studebaker of his own design show you what he scans and what it looks like after he's finished manipulating it in the computer. He told me that the renderings were coming out so photorealistic that he had to loosen up his technique so that the sketches look like art instead of photographs.

◀ Another view of Charlie's *Super Stude* has those typical Charlie Smith reflections and details that make it unique to him. Note how he sneaks in some blue sky tones to help the surfaces of the Stude read as one-, two-, and three-box sides. Also note that even the best artists use perspective guidelines to make sure they are keeping it real.

83

I include this computer drawing by Jim Bruni to show that using the techniques available on the computer helps to create all kinds of variations of the predictable blends and gradations normally seen in computer images. There are no blends here, and the details are obscured and simplified into a graphic treatment meant to add interest and remove it from typical computer generations. This was created on a Macintosh with Macromedia Freehand to commemorate Rudi Caracciola, who was known as "Der Regenmeister," or "rain master," for his mastery of driving through heavy squalls.

✚ BERN, 21. AUG. 1938
V. GROSSER PREIS DER SCHWEIZ

▲ Some would call this cheating, but if you knew how qualified Ed Golden is in the automotive art world you would know that even though this started out as a photo, it takes an artist (or, in Ed's case, a designer) to give you what you see here. Ed manipulated the car image and added his own brand of color, smoke, and backgrounds garnered from other pictures he has taken. It was all thrown into the pot and ended up as this incredible Golden "stew." The Charger was just sitting when Ed took the shot, but not after he worked his Mac magic!

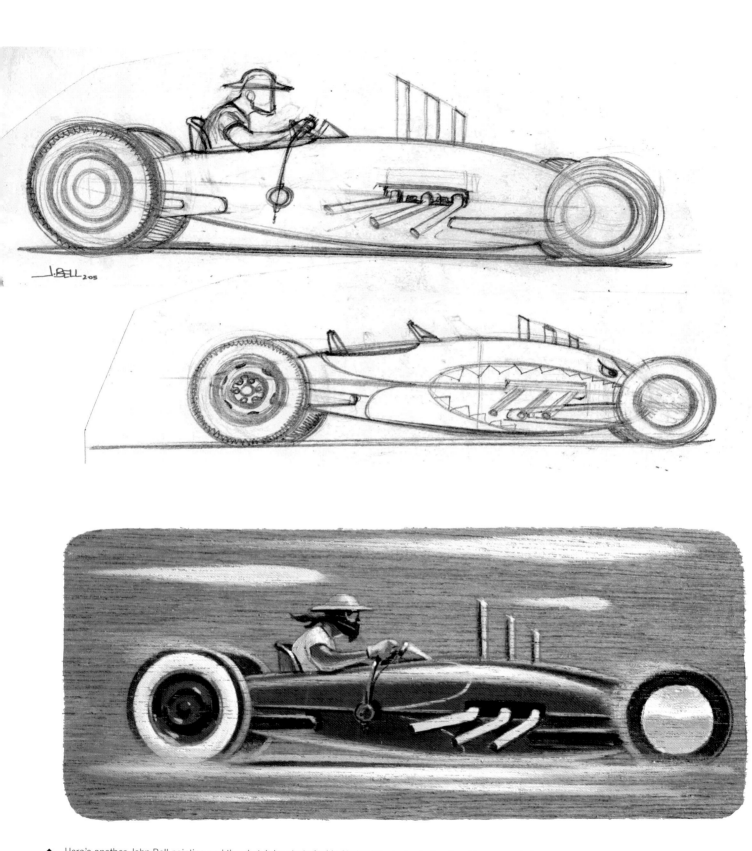

▲ Here's another John Bell painting and the sketch he started with. Notice how he is starting to add more gradations for his highlights, reflections, and even the skin tones of the driver. It is unmistakably John Bell, but over the three or four years he's been doing these wood paintings he's developed his technique.

Dave Bell's medium is India ink on heavy paper, but his style is definitely unique and definitely Dave Bell. He exaggerates proportions, lowness . . . virtually everything. And, most obviously, he fills up every speck of paper with art—no negative space here. It's his style—his technique— and it's worked for him for 40-plus years. (Dave, don't get mad at me for saying how long you've been at this!) As they say, "Always copied, never duplicated."

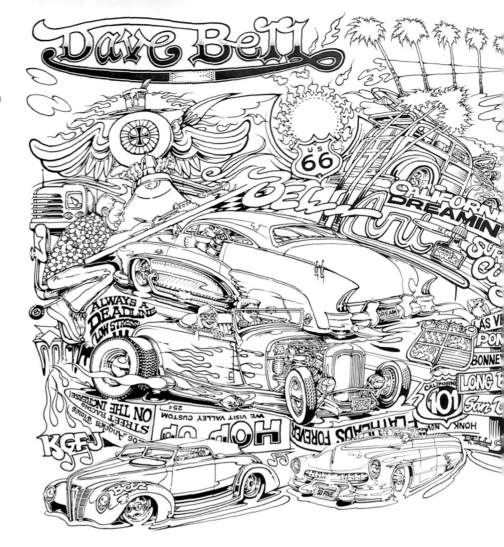

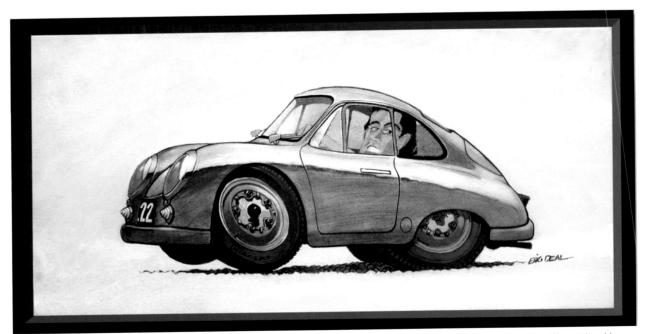

▲ Done strictly as a wall hanger for comedian Jerry Seinfeld, this Dave Deal rendering is included here because it's a little different than his normal stuff, but still looks like "Big" Deal did it. It's mainly done with marker and colored pencil and is distinctly Dave Deal in its proportions, exaggeration, and general setup. Dave knows Porsches intimately, so he knows exactly what to exaggerate and how much detail to include.

Color

Color enriches a sketch with added interest and dimension. When used effectively, it is an eye-grabbing tool. It draws the eye into the sketch and helps give an added dimension, thanks to a few simple tricks you can try. However, color can just as easily ruin a sketch if overworked or used in the wrong manner.

Having a good range of colors available, whether they are markers, pencils, or chalks, helps you blend and highlight color with color. If your funds are limited but you're itching to try color in your drawings, start with a range of colored pencils or markers within a particular color, such as blue. Building up, or layering, your drawings works better with a range of one or two particular colors. Having a good

▼ This line sketch is what I used as an underlay—all of the perspective, proportion, and details were figured out at this point. I used to leave some of the details until I actually got into the rendering, but I found over the years that if I didn't like what I came up with in the final, I was stuck. So make your drawing mistakes and corrections at the underlay stage so you're ready for your final art before you start.

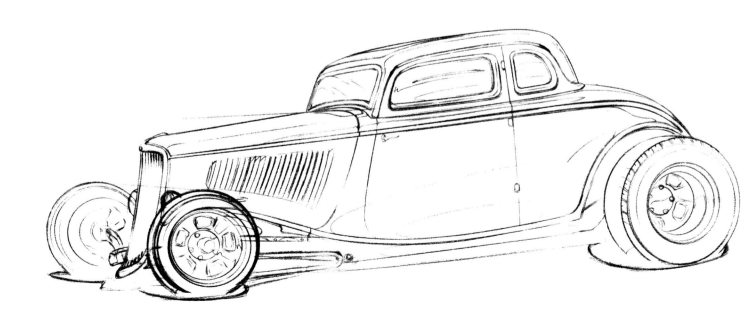

range of one color is better than a beginners' set consisting of a green, a red, a blue, etc. Then, if you feel like you want to develop this further, you can begin to get into other ranges of colors to gradually fill out your pallet.

When it comes to color, there are color theories like the classic Munsell and Ostwald color systems (used in most art schools), things like tinting, contrasting

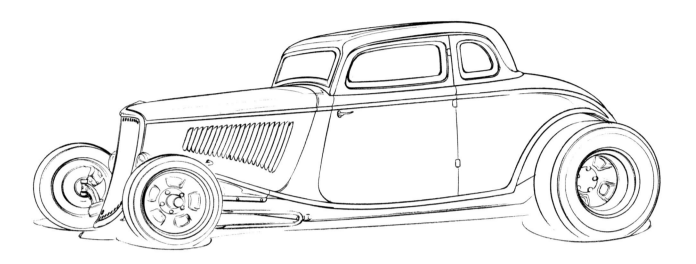

▲ A tight line sketch from the underlay is how we start off. I use the perspective guides in my underlay to make sure this sketch is right. The drawing is being done on bond paper, partially because I can see through it just enough to trace from my underlay, and partially because it has a nice "tooth" and doesn't puddle the markers—nor does it suck the marker juice and spread it around like a paper towel.

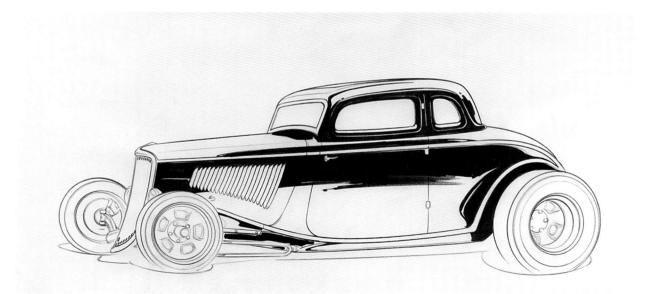

▲ The black marker represents something out at the horizon that is substantial enough to reflect into the body side from midway up into the top. I want as much as is reasonable of this initial reflection to represent the color of the car. As the upper surfaces like the top and hood turn and face away from us, they also face away from the reflection, which stops the reflection. The bottom-of-the-body reflection is stopped loosely here, but you may choose to make it a cleaner line. It stops to indicate that the ground reflecting into the car is closer than the horizon. This gives us reason to have a nice gradation in this area to define the body as it slowly pulls in toward the frame.

colors, complementary colors, and so on. But for drawing a car, we are not dealing so much with systems or theory as we are trying to depict a car in a particular color. It's not as simple as it sounds, but it is fairly easy to master. So let's concentrate on car color theory and leave the other information for another time and another book, perhaps one on color that you find at your local library or bookstore.

Cool colors such as blue, purple, or green tend to recede or go back into a perspective sketch. Warm colors such as yellow or red or orange come forward in a sketch.

A trick when doing a color sketch: Use a warmer version of the car color for areas closest to the viewer, which is you. Similarly, to get portions of the car to go back into the drawing's imaginary perspective space, use a cooler version of the car's color. And as you learned in Chapter Three, as you go back into that space,

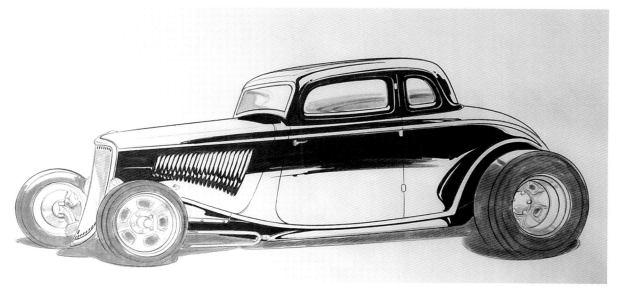

▲ I forgot to run some of the body color into the hood louvers, so I do it here. The dirty orange will act as the background color for our shadow and tires, stopping at the very tops of the tires for the gradation I plan to put in later. Also, I have put reflections into the side window, windshield, and a little creeping into the wheels, grille, and brake rotors. Technically, the reflection in the upper portion of the top would stop at the same point as the reflection in the side window, because it is reflecting the same thing, but I'm using that famous artistic license deal. I want to keep the reflections in the upper portions of the top simple because there is so much detail, such as the reveals around the windows and the raised peak above the door. It helps to define these details better if I'm not trying to run gradations or reflections here.

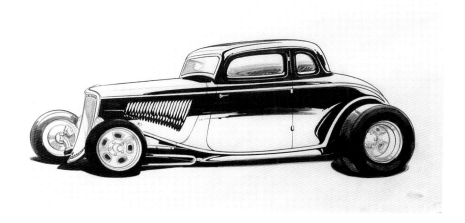

◄ I only want a tint of orange throughout most of the shadow and tires, so now I come back with the black marker and fill in a lot of these areas. But I want to have some gradations to indicate the shapes of the tires, so I blend in a gray marker to lighten the upper portions of the tires. The tires farther from the viewer are lighter than the driver's front tire, which is closest to the viewer. The window reflection was a little weak, so I also plug in a darker gray.

▶ I want to try and finish off as much of the drawing as I can before getting into the messy part—chalk. I work with chrome indication in the wheels, front end, windshield frame, hairpins, and grille. Basically, it's a matter of drawing in sky blue for the chrome surfaces facing up and a warm brown for the surfaces facing down. You have to be methodical and consistent to make it all read properly.

▲ Here's where it gets fun, messy, and scary—chalk time! After masking off the paper around the image—either with drafting tape (don't use masking tape) or clear frisket (as I have done)—I start swiping the chalk. I load the blue into the upper surfaces facing the sky and a warm brown for areas that reflect the ground. I lighten up only slightly on the chalk as it goes up into the car at the top, and down as it runs through the body sides. I'll lighten it up where I need to once I get the black chalk into the drawing. I'm not done swiping chalk yet.

▶ After washing the chalk off of my hands, I run the black chalk into the areas where the black will be most concentrated in the body, being careful to not go overboard. You can always run some more in if you need more, but it is almost impossible to eliminate it once it's down. Look closely at where I've scratched in the black.

▲ You can use cotton pads, but I use my handy fingers to smooth the black into nice, consistent blends, making sure that the underlying colors come through as I move away from the concentrations of black. Because I have my film or tape protecting the paper surrounding my image, I can take sweeping smears to get nice, clean gradations. This takes practice. If you've loaded up too much black, you might try and come back with your blue or brown and see if you can't get some of the color back. This will read as a fairly dull black car unless you can get that blue and brown to show through. The gradations on the upper surfaces get lighter because the reflection being picked up is of the lighter portions of the sky, and the browns at the bottom of the coupe get lighter as they come closer to the car because the ground—as in the white paper surrounding the car—is light. So, I indicate the light paper being picked up by the lower portions of the body as the body tucks in to meet the frame. This would be the same on almost any car because they all tuck in as the bodies get closer to the ground.

you will also want to make the car lighter in value. These changes in color should be very subtle and used more as a veiled trick than something overt. If the change is too obvious, it becomes distracting and you lose the effect you are trying to achieve. It may even give the illusion that the car is painted in a blend of one color to another on its surface. Once you master the use of color on a car, this might be a fun experiment to try. But for now, let's concentrate on a single color.

Here's another trick to use with color: Since a car is almost always viewed outdoors, the sky casts a subtle blue over the surfaces of the car that point upward. But don't forget that those surfaces pointing up also get lighter, as in the one-, two-, and three-box examples in Chapter Seven. And just as the sky reflects from above, the ground reflects into the lower portions of a car body. The ground will cast a warm or yellow/brown tone into those lower surfaces. With the cooler sky tones in the upper surfaces and the warm ground tones in the lower portions of the body, your rendering will start to take on some real-world characteristics. As you start thinking about the use of warm and cool tones, try to experiment to decide how far you want to go to introduce these cast tones to your drawing. Too little and you hardly notice, while too much makes for a strange circus wagon look to your rendering.

There is another pit to avoid falling into when applying color to your drawing. If you are too timid with your colors, you can give the illusion that the car is made of tinted glass. The drawing takes on a characteristic of being visually lighter than air. So when you lay in color, try to remember to keep "volume" in the drawing. The car is a very heavy, solid object. You want it to have that appearance in your drawing. If the car is a light color to begin with, the variation in value will become less. The No. 1 side of your imaginary box may be only slightly lighter than your No. 2 side. I know this is a lot to remember, so try these suggestions a little bit at a time. Keep referring back to this and other chapters for these useful tips.

▶ After washing my hands again, I spray fixative over the drawing to keep the chalk down and then I let it dry. I can then peel up the tape or frisket and look over what I have and start noodling. Highlights in the body can be brought up with a white pencil or with an eraser that has a nice sharp edge to it. Clean away any areas of chalk where you wish for there to be highlights. I run an extra reflective line through the lower body to break it up a bit, clean up the louvers, and generally take my time to finesse the body now that 98 percent of the drawing is finished.

▶ With white gouache and a No. 0 or No. 1 Windsor Newton brush I put in my pigeon highlights and, in some cases, come back in with a white pencil to help the highlight travel a bit more. A blue outline runs around the car to help frame it and separate it from the background, but also to give a subtle indication that the body is picking up more sky tone as it makes another turn away from the viewer. I can never leave well enough alone, so I noodle some more at this stage.

▲ For the last flourish, I put in a simple marker background, letting some of the white paper come through so that we don't end up with this heavy-looking thing behind the car. Keep it light, simple, and clean. I also dust in some brown chalk at the base of the car to soften the transition from car to paper foreground. Now sign it and go get a cup of java—you're finished!

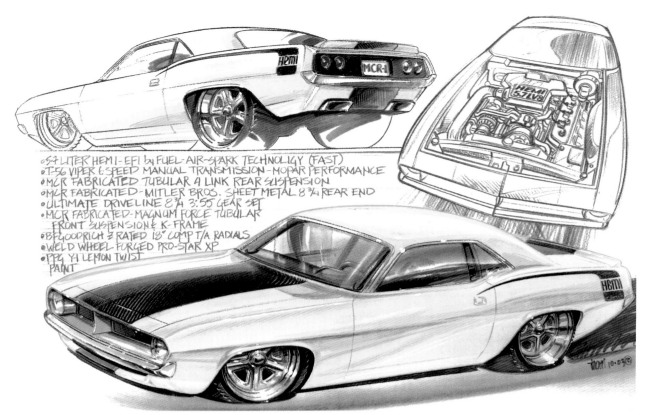

●5.4 LITER HEMI - EFI by FUEL-AIR-SPARK TECHNOLIGY (FAST)
●T-56 VIPER 6 SPEED MANUAL TRANSMISSION - MOPAR PERFORMANCE
●MCR FABRICATED TUBULAR 4 LINK REAR SUSPENSION
●MCR FABRICATED - MITLER BROS. SHEET METAL 8 ¾ REAR END
●ULTIMATE DRIVELINE 8 ¾ 3:55 GEAR SET
●MCR FABRICATED - MAGNUM FORCE TUBULAR
 FRONT SUSPENSION & K-FRAME
●BF GOODRICH Z RATED 18" COMP T/A RADIALS
●WELD WHEEL FORGED PRO-STAR XP
●PPG Y1 LEMON TWIST
 PAINT

▲ Sometimes less is more, as in the case of this sketch for Muscle Car Restorations in Wisconsin. There is a lot of information, both written and visual, so the idea is to keep the colors to a minimum so that they don't compete with the images and information. Note the carbon-fiber indication on the hood. This car utilized an aftermarket carbon hood and the client felt this was important to show. The point is you need to be versatile at indicating different surfaces. As you can see, it doesn't need to be complicated or really detailed.

▲ Whenever using color around the car you've drawn, make sure you bounce a little of it into the appropriate surfaces of the car. It's fun, and it helps tie the backgrounds into the car. It can also help define surfaces, as with the top of this fastback Corvette. The green in the foreground is reflected in the rockers of the car, while the blue background is reflected in the top.

▲ I like to play around with color, and I like to use contrasting colors to see if they work together. That was the case with this '65 Impala. Green and orange are normally harsh together, but I tried to use the best hues of each to help them play off of each other. You'll note elsewhere in the book that Steve Stanford likes to use red shadows as a base for some of his drawings, in the same manner that I used green here.

▶ This is another example of using contrasting colors to help punch up the color saturation. This is a little different than the Impala example because I'm trying to integrate the turquoise a bit more into the tires and shadow. The color range is fairly tight, with the yellow/green, turquoise, and royal blue as the three major colors, and just a little red for the wires to help draw attention right into the middle of the drawing.

▲ The computer rendering makes for a dramatic presentation (and breaks a few rules) by utilizing a red background with a red car. This is a bit difficult to do because you want your car to read against the background and pop off of it. Ed Golden's approach works because he uses components, decals, and paint graphics on the Formula 1 Ferrari to define the profile and push it away from the background. And dropping in a reversed, knocked-back version of the car as a reflection really helps to plant the car on the ground.

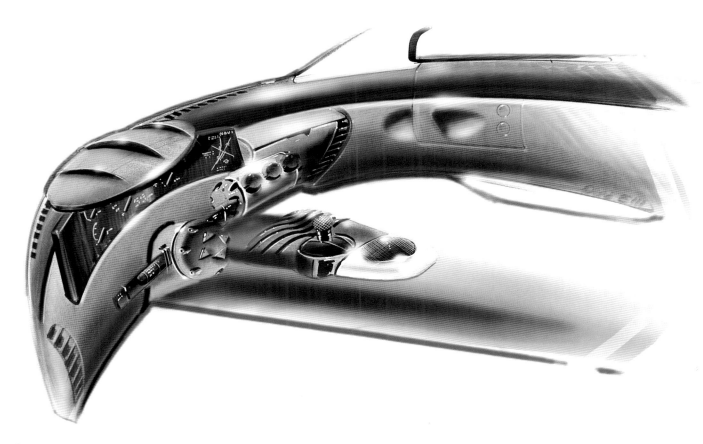

▲ Sometimes you can use color to help pull the viewer into the sketch. Danny Ellis has done that with the colors he chose for the instruments in this interior sketch. It's basically a black and red computer sketch, but the specks of color in the instrument panel catch your attention, as do the white highlights and lettering, which contrast nicely with the fluid blocks of red and black soft parts.

▶ Greg Tedder can always be counted on for using rich, saturated colors in his T-shirt presentations. By limiting his choice of colors, he uses them to play off of each other. Here, blue is used next to yellow-gold and red-orange. Sticking colors next to their opposing or contrasting colors pushes their brilliancy. The darkness of the windows and the black shadows also add to the saturated feel of his designs.

▶ Big Deal's poster art uses a lot of colors, but there is a trick here. He uses warmer colors for the cars closer to the viewer, and cooler colors for the cars farther away. Warm colors come forward, cool ones recede; thus, his use of color gives depth to the scenes he creates. Though there are a lot of colors used here, it doesn't come off as a "circus" because the colors farther back are more muted, while those closer to the viewer become more intense. Even the grass is cooled off as it moves farther back in the scene.

Presentation

Say you've got a pretty decent sketch of a Viper GTS coupe but you need some way to enhance it rather than just letting it stand alone. This can be as simple as adding a background or border, or as elaborate as positioning it with buildings, people, and cars in a realistic setting. While there are many ways to come up with enhancements for your sketch, we are merely touching the surface with these examples.

One thing to keep in mind with backgrounds is that they can become part of the illustration itself if they are placed too close to the subject. This can be good or bad—depending on what you are trying to accomplish. If the background is too close, you have the option of casting a small amount of its color into those surfaces of the car that are either near the background, or pointed in its general direction.

The other option is to reflect part of the background into the car. If you choose to do this, you must do it in a way that keeps the car and its background separated. Again, that background is only an enhancement. It should not over-power your work. Elaborate framing devices or backgrounds are best left with the Baroque works of the 1600s. We're way past that, man!

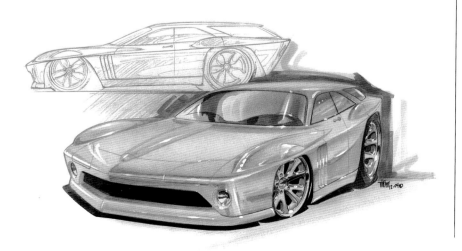

◀ My idea of presentation is very basic: the main image with a simple background and maybe another sketch of the car from a different perspective to allow the client to see it from another angle. That's about it, but I feel it helps to keep the focus on the car. And, really, these drawings are tools to help the client figure out what he and I want—or what we want the fabricator to build. Elsewhere in this chapter are plenty of examples of really creative presentations from other artists.

▶ Because this is a rock crawler it has a rather awkward look. Some might mistake it for being badly drawn. The bodies on these dudes are really narrow, and the tires stick waaaaaay out beyond them. I tried to use a very simple background to help place this vehicle in its natural surroundings and give the viewer the idea that this is not your typical 6-mpg-on-the-highway, gas-guzzling H2. Also note that the background is reflected back onto the hood because that is what would happen in the real world.

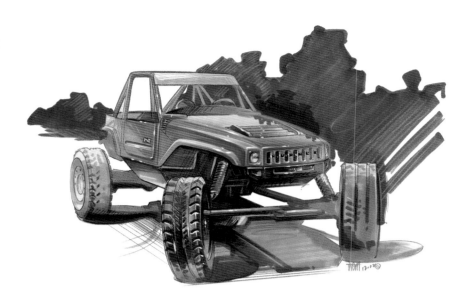

▶ Sometimes you want your car art to convey something other than just sitting there. In that case, the views you choose, how you place them, and what you place around them will determine whether or not you succeed. Jim Bruni wanted to depict a scene from the original Pan Pacific Road Race of 1913 showing the drivers and crews struggling with their cars, throwing them around curves, and barreling down a road. He accomplished this and more. By taking a simple graphic approach to the background and keeping to a strict color pallet, he was able to give the poster a vintage look and feel.

◀ This Dan Ellis sketch is what I would call a classic Art Center College of Design sketch. The presentation is simple but full of interesting effects. The green background has been brought into the rear tire and driver's side front tire for interest's sake and to help push these objects into the background of the sketch. The background is also plugged into the window reflection and dropped into the hood, windshield, and top as would happen in real life. This helps to integrate the whole sketch, add realism, and define the surface changes on the hood. Instead of just being a background, it becomes a tool to help define the design while also keeping the viewer interested.

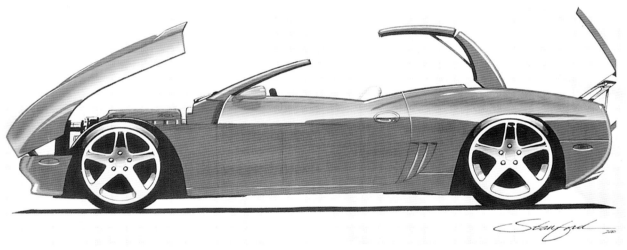

▲ Sometimes you can show the mechanical aspects of your subject. In this case, Steve Stanford grabs your attention by showing the interesting articulation of the hood, top, and trunk. Showing your design all cracked open exposes hinges, understructure, and mechanical components, which all add realism and show that you know more about cars than merely being able to draw them. Also note the simple reflections that don't distract from the overall design or what's going on.

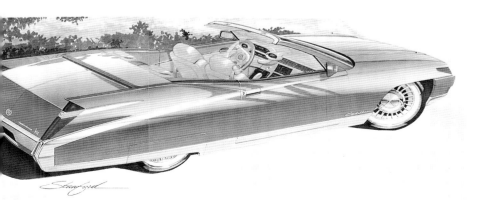

◀ Steve loves his Cadillacs and has done many design sketches over the years. One of his favorites is this convertible, incorporating some of the great cues from their past into a cool Cad for the present. Steve likes to add simple tree/shrubbery/cloud backgrounds that take only a couple of minutes with a marker. He reflects them into the deck as they would do in the real world.

▶ Darrell Mayabb's presentation is fantastic on this poster for the St. Ignace, Michigan, car event. All of the elements—the cars, bridge, sky, and even the brush streaks—emanate from the center of the poster to draw your eye right into it. The car views have been carefully chosen to angle out from the center and to sit on a plane that comes toward the viewer from the center. It really works!

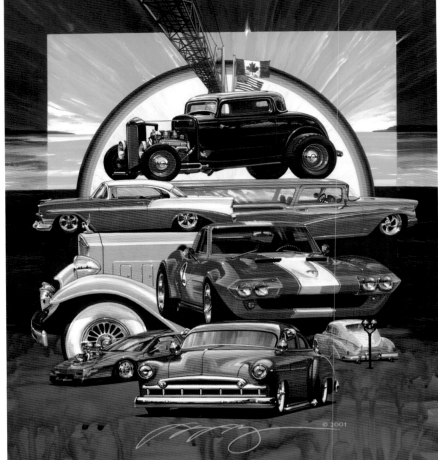

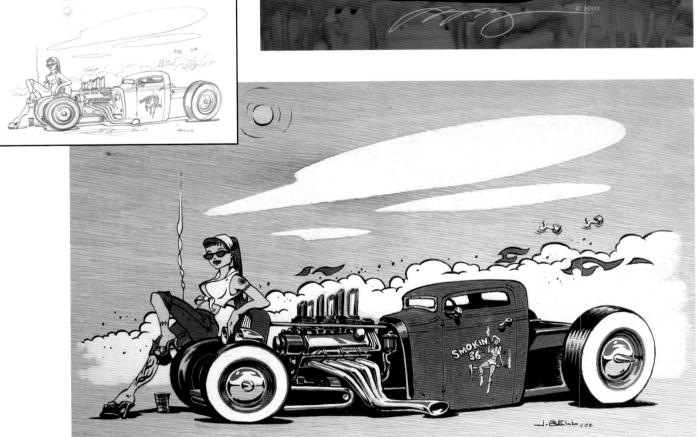

▲ When I'm at a drag race or hot rod run with John Bell he's always taking pictures. Girls, cars, engine details—everything! Now you and I can see why: He uses it all to create his paint-on-wood art. With the wood grain as a subtle background, he uses a limited pallet and simple graphic elements to re-create this retro rod world. The simple but bold graphic elements, varying line weights, and well-drawn girls all add up to a sketch you really want to look at for a while. Included is the pencil sketch that John traced to create his painting.

CAN'T WE ALL GET A LONG....

◀ This cartoon is classic Dave Deal work, but he's added the element of a subtle and fairly detailed background from an unrelated painting to help give the feeling of cruising along the street. And because the concentration of colors holds together, it pulls you into the drawing because the colors do not fight for your attention. Presenting the drawing this way gives the work a different effect than we are used to in a Big Deal drawing, and it works.

STREET AND HAVE A RACE

A RACE IS A TERRIBLE THING TO LOSE

◀ Greg Tedder's shirt art is probably the finest in the country today. The cars look cool and the colors are bold and saturated, which helps give them a really solid feel. Thanks to his restraint with color, your eye doesn't fight with a bunch of colors all vying for attention. The graphic elements he uses either frame the design or pull your eye into it.

▶ Another Greg Tedder shirt design, this one utilizing simple graphic elements that are reflected into the hood and windshield of the Camaro. The colors are rich and bold, which helps the design pop off of a white T-shirt. Greg starts out with an inked design then comes back with the computer to plug in the colors. From there, he has a program that separates the colors for silkscreen printing.

▶ Sometimes, placing your car in an unlikely setting captures everyone's eyes, as is the case with Ed Newton's *Cosmic Cord* sketch. Originally done with gouache, Ed scanned it into his computer to capture a more surrealistic setting than if he had merely depicted it cruising down the road. It also helps to convey that even though this is based on a car design from the 1930s, it is intended to be from the future. The blue outlining of the upper surfaces and gold outlining of the lower surfaces help to establish the car as black while setting it off from the black background.

Cartoons

Virtually every time you freehand sketch a car, you have created a cartoon. Why? Because you have exaggerated the car or drawn it slightly out of proportion even if you didn't intend to. Stretching, squishing, leaning, and tilting—the more there is, the more you've removed your sketch from reality. But it sure is fun. Some find it easier to draw a cartoon of a car, while others find it a bit more difficult than doing a straightforward sketch.

If you find yourself drawn to this naturally, that's fine. For those who wish to enter the zany world of cartoon fun but find it a bit hard to grasp, you may want to concentrate on first drawing a car as well as you can. Once you reach a certain comfort level, you can then ease over into the cartoon world. By taking your ability to draw well-proportioned sketches and then exaggerating them a bit, you can explore changes in the relationships of elements that make up a car sketch. Chopping a top is the easiest proportion change to sketch. Exaggerating the sizes of the wheels or tires is another. Body proportions heightened or reduced, elongated or squeezed, can give your drawing any feeling you may want to convey.

Rather than have me blabber on, check out the accompanying examples, culled from some of the best in the business. Many of these artists have been doing this for more than 30 years, so don't be intimidated by the high quality displayed here.

Study what makes these drawings so special, and practice giving your cartoons that same look. Notice how each of the artists shown here has his own unique style. Strive to come up with a look that is uniquely yours. But most important—have fun!

Dave "Big" Deal

Deal is one of the premier cartoonists in the country. His reputation is such that when Pixar needed ideas for the 2006 Disney movie *Cars,* Dave was called up to help define the overall look of the car characters. He uses a number of techniques to get that Big Deal look. Initially, he sketches his idea in pencil and then scans it into his Mac to blow in the color and textures. Sometimes you'll see pencil shading as an underlay for the color he puts into the drawings. Occasionally, he still likes to paint in the color, as in the Porsche 911R cartoon done for comedian Jerry Seinfeld (see Chapter Nine).

Lance "Jersey Suede" Sorchik

Lance loves hot rods—how else can you explain the kind of detail he includes in every cartoon? He has built a number of cool hot rods, including a '32 Vicky he did along with his wife Diane—for Diane! Over the years, he has become a computer convert, sometimes sketching his cartoon before scanning it and coloring it in the computer. Other times, he enjoys taking actual photos and manipulating them into his contorted signature look. Earlier sketches show his use of stippling, or shading done with little dots. Lance and Diane are both art teachers in Sussex County, New Jersey.

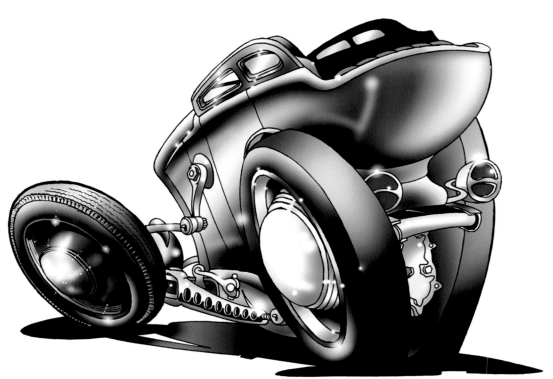

Dave "Henry HiRise" Bell

Dave has become a celebrity from his beloved "Henry HiRise" cartoons that have appeared in almost every issue of *Street Rodder* since its inception—going on 35 years! He does more—like pinstriping, T-shirt designs, and posters—all from his home turf of St. Paul, Minnesota. His style is lighthearted and fun, and done almost exclusively in India ink on heavy paper stock. Sometimes he will create a color rough for a T-shirt company to follow for silkscreen color placement, as seen in the color examples shown here.

Ed Newton

Ed is an icon in the auto art world, having established the look of "weirdo" or monster art in the 1960s when he created all of the cool shirt designs for Ed "Big Daddy" Roth. A lot of artists (including myself) have imitated the genre, but no one has done it better than Newt. Back then, his technique was to use a paint brush to do the line work—no pens were used. Today, he draws his cars out with pencil, scans them, and colors them up on the Mac. Sometimes he'll still pick up a brush and paint with gouache, as in the example of the green highboy roadster racing a train.

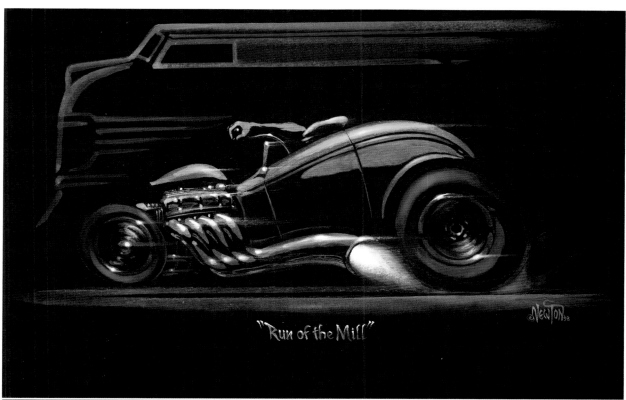

"Run of the Mill"

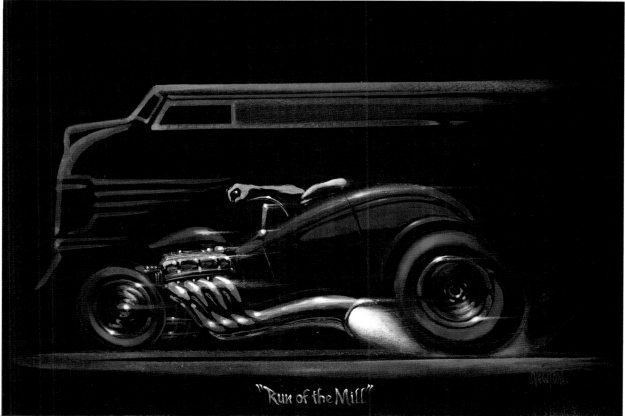

"Run of the Mill"

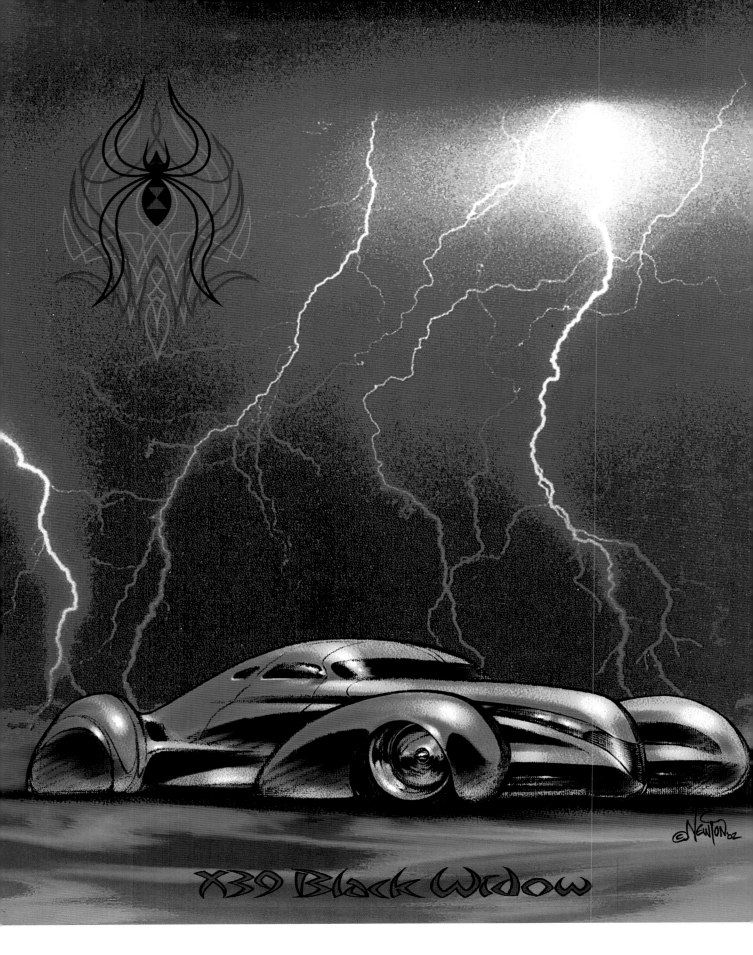

X39 Black Widow

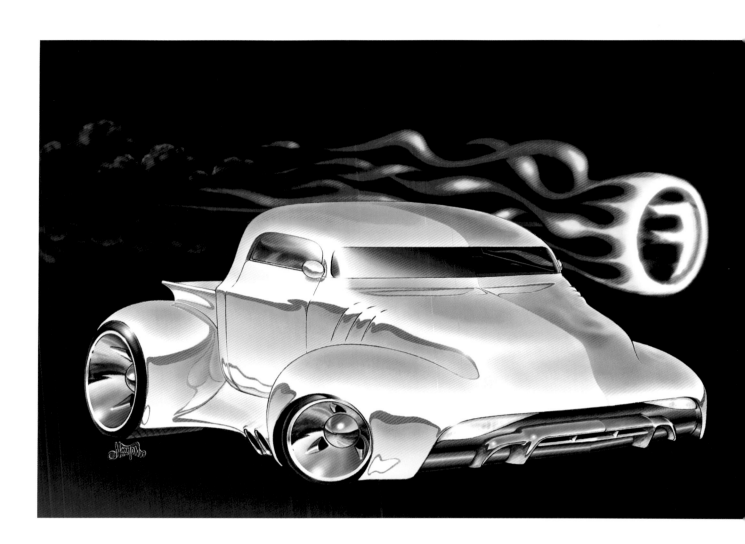

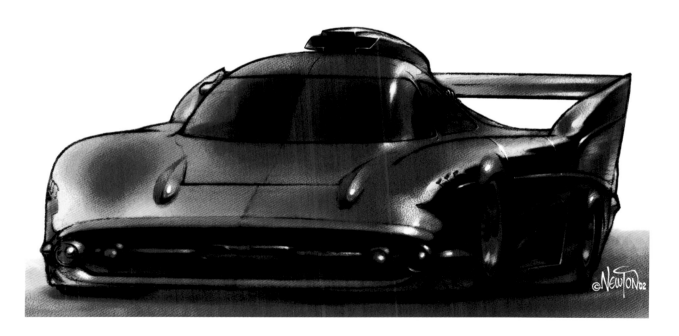

Thom Taylor

I've included a few of my own cartoons for comparison. Though I don't do a lot of this work, I love it when the opportunity arises. I have had the pleasure of drawing the Frog Follies rod run art for over 15 years. I usually do the art in pencil and then harden up the lines with a fine-line pen and come back in with color markers—even doing the gradations with the markers. I've also been bringing myself into the present by doing some of this work on the computer. Yes, I know I'm a little late to the dance!

Cutaways

A cutaway of a car is like one of those detailed inside-the-human-body draw-ings with the skeleton, organs, and a virtual road map of veins and muscles: all the guts and glory.

If you've ever marveled at the complexity of a cutaway drawing, you've prob-ably wondered how the artist did it. Although I have only done a few, I feel that if you know your perspective, have an interest in things of a mechanical nature, and own a good camera, then you are able to do a cutaway. Oh, yeah—you need to set aside a lot of time. Despite what you might think, drawings of this nature take quite a while to set up and even longer to complete.

The best subject to choose is one in which you have a lot of interest (for you'll be living with it for quite a while), and one on which you can get the greatest amount of reference material. That means being able to take a ton of pictures of as much of the car as possible. A popular car with lots of magazine coverage might be a good subject simply for this reason. You may want to consider a race car as a first try; with the body removed, many of the internals are revealed for which you need photographic reference for an accurate, detailed drawing. If your choice has limited reference available, then you will need to track down the informa-tion. Illustrator Tom West uses more than 200 photos for a single cutaway! When it comes to reference material, you can never have enough.

It is this build-up of material that gives you a good foundation for any cutaway endeavor. The first step is to draw the body and the frame separately on tissue or tracing paper, in the same perspective. This begins the preliminary drawing version. Almost universally this perspective will be a front elevation, which tips the car up enough to show most of what is going on from front to back. You may want to trace this initial attempt from a photo. From here, it is a step-by-step process of building up the components. Draw them on separate pieces of tissue paper, so that if you make a mistake, you don't have to junk everything you've created up to this point. Obviously, they must all be drawn in a scale and perspective that tie into what you have drawn for the body and frame.

Since you will probably be playing one component off another and scaling from one to another, you should start sketching in the big components such as the engine and transmission; consider adding the wheels and tires soon, since many

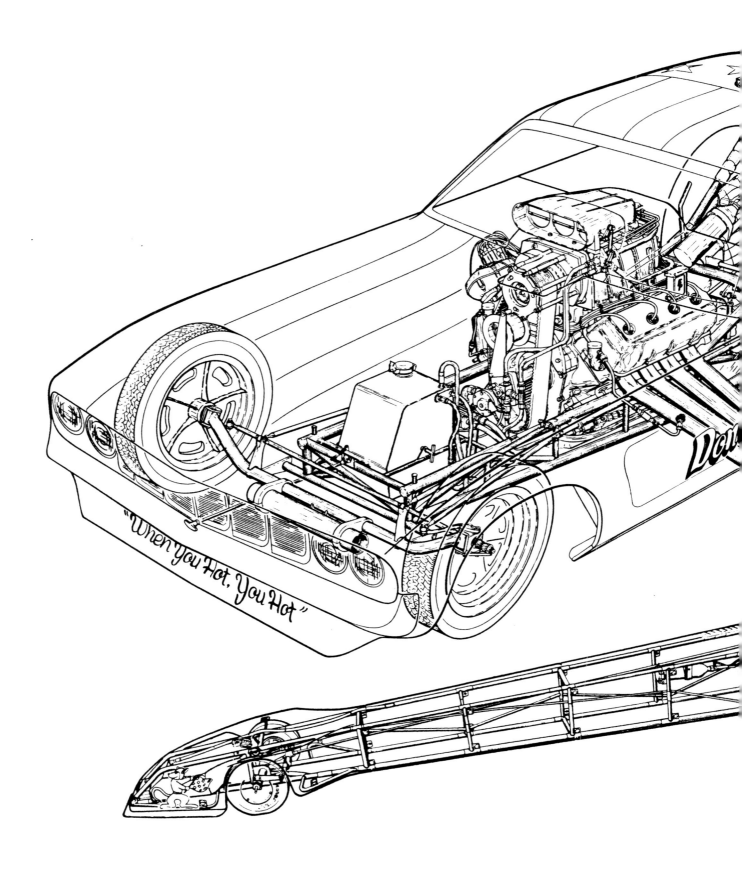

"When You Hot, You Hot"

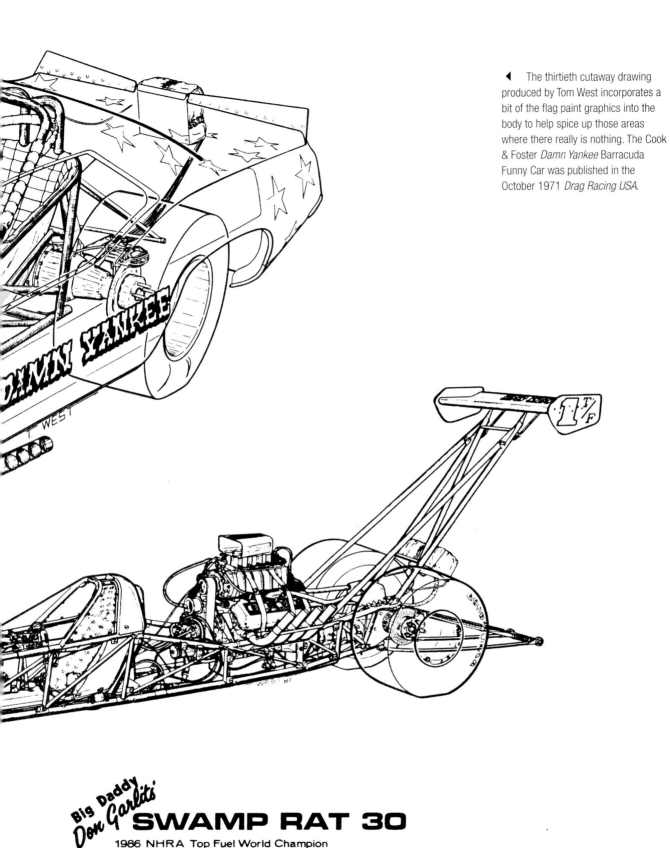

The thirtieth cutaway drawing produced by Tom West incorporates a bit of the flag paint graphics into the body to help spice up those areas where there really is nothing. The Cook & Foster *Damn Yankee* Barracuda Funny Car was published in the October 1971 *Drag Racing USA*.

Big Daddy Don Garlits'
SWAMP RAT 30
1986 NHRA Top Fuel World Champion

This cutaway hung in the Smithsonian Institution as a backdrop for the display of the actual Garlits *Swamp Rat XXX* Top Fuel Dragster. It's the thirty-fifth cutaway drawn by West, completed in 1987.

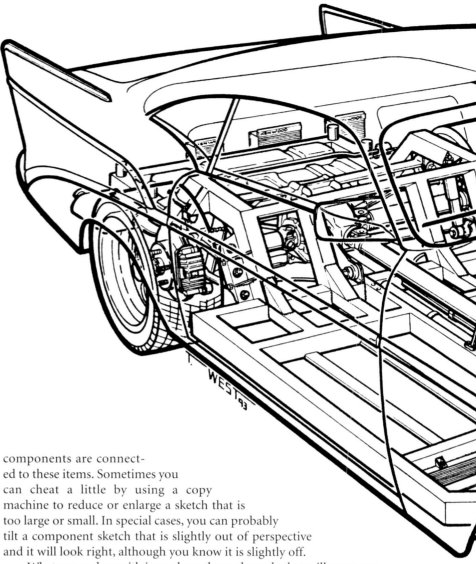

The Boyd Coddington–built *Chezoom*, a car I designed for Joe Hrudka, was a difficult car for West to draw. There was little time to shoot reference photography on the car; this overall view was a result of the weird camera angle and lens required due to the cramped space where the car was built. I had to call certain styling shots for the car with extremely limited viewing space. As the unique angle of this cutaway has grown on West, so have some of the compromised styling modifications grown on me.

components are connected to these items. Sometimes you can cheat a little by using a copy machine to reduce or enlarge a sketch that is too large or small. In special cases, you can probably tilt a component sketch that is slightly out of perspective and it will look right, although you know it is slightly off.

What you end up with is one huge, layered puzzle that will serve as a basis for the final version. With the use of a light table you will do your final drawing with all of these earlier, separate drawings placed together. From here on it is just a matter of drawing each component in place, in perspective, and with a pen or pencil. Shadows and/or color can be added once this stage of the drawing is completed. In my color cutaway, I found it necessary to outline certain components in a dark gray to help separate them from neighboring components. You may or may not choose to try this; it works for me.

The two artists featured in this chapter come from very different backgrounds. Tom West has an engineering background, as well as a love for drag racing, and a pretty good eye when it comes to photography. You may see his byline next to a lot of vintage drag racing photography. Darrell Mayabb's background is in both fine and commercial art, and he too has a good eye when it comes to a camera lens. While Tom's workload has precluded him from doing a lot of cutaways as of late, Darrell finds it to be a lot of fun and also in demand, so his cutaway output has ramped up more recently.

Technically, this is one of the most difficult drawings to execute, but it is also one of the most rewarding. It can be both informative and entertaining, and you will find that some people will stare, transfixed, at your work of art. You may find that you will want to deviate from the steps I have laid out, which is just fine. What works for me may not work for you since this is such an involved creation, so don't feel tied to these steps. Good luck!

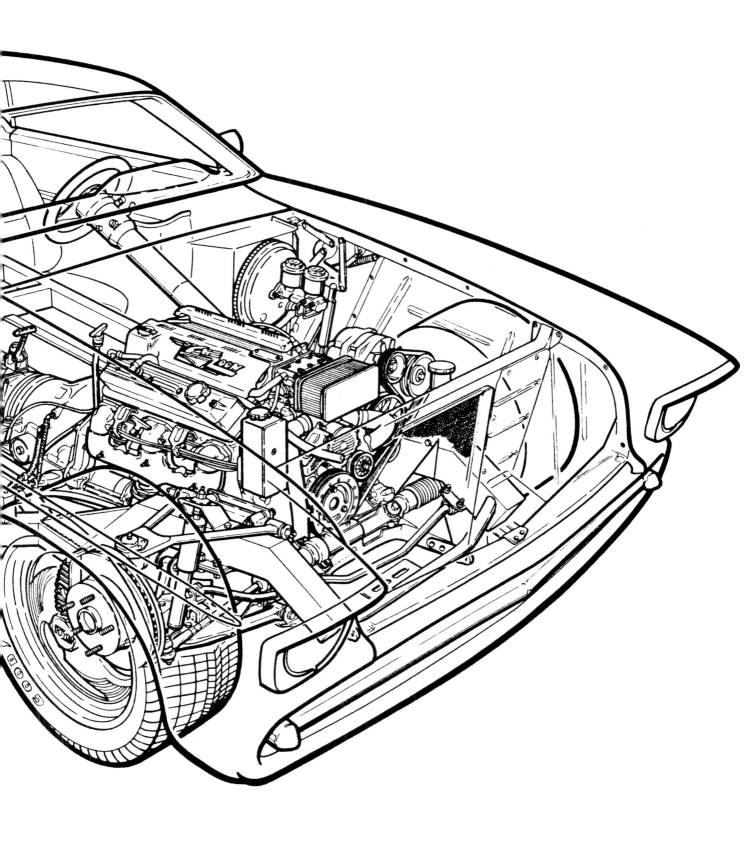

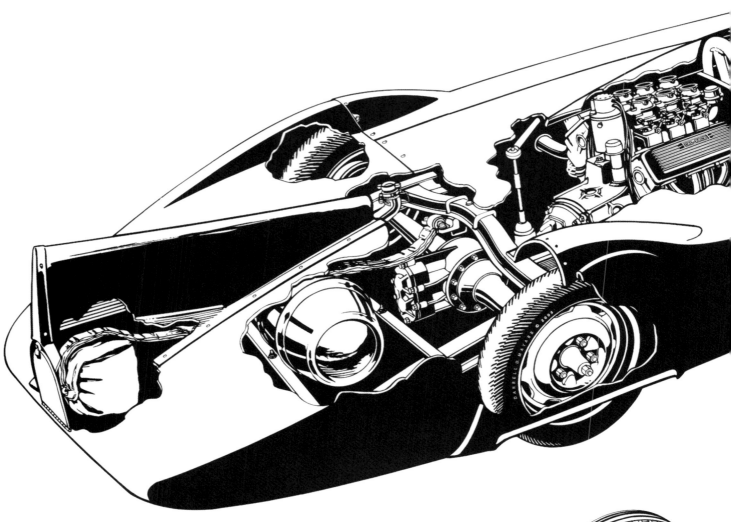

▲ The original *Golden Rod* Bonneville streamliner built by Tommy Thompson is Darrell Mayabb's subject here. This high-angle view is a little forced for a car drawing but a great angle to show details in a cutaway. The dark body panels give the drawing more contrast and make it a little more "punchy" than Darrell's *Ala Kart* cutaway.

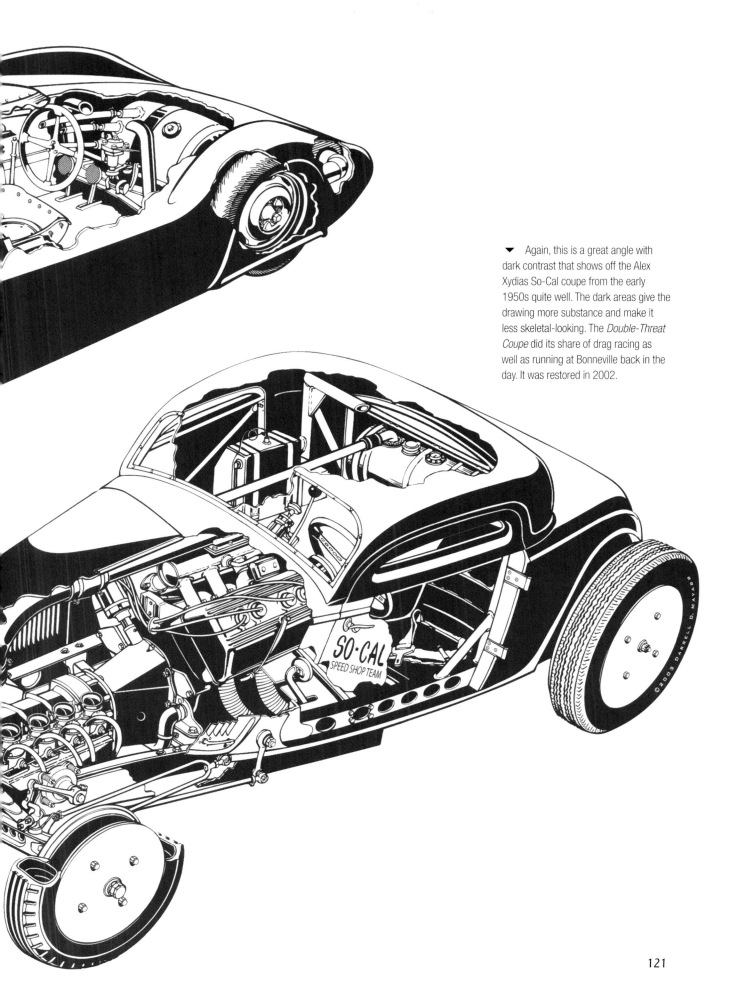

▼ Again, this is a great angle with dark contrast that shows off the Alex Xydias So-Cal coupe from the early 1950s quite well. The dark areas give the drawing more substance and make it less skeletal-looking. The *Double-Threat Coupe* did its share of drag racing as well as running at Bonneville back in the day. It was restored in 2002.

SO·CAL
SPEED SHOP TEAM

©2003 DARRELL D. MAYABB

Interiors

Sketching an interior can be a little like doing a cutaway in that you are sketching several separate things within the confines of a particular perspective. Instrument parts and components, seats, and door hardware are part of a larger whole. With interiors, however, there is much less to create, and much of what you create has a similar surface finish. That finish is almost never shiny, so watch it. Since I don't regularly do seats or dashes, I have to be careful that I don't give the impression they are made from a shiny material. Rendering a hard, cold surface does not make for an inviting car interior.

Because there aren't any highlights to help you define or separate surfaces, you are forced to be a little more precise with your one-, two-, and three-box lighting. Defining each undulation and surface change will help you visually describe your interior. And the light source will determine shadows, which become another tool to help you define surfaces. Shadows also add a darker, or No. 4 value, to complement your No. 1, No. 2, and No. 3 values.

▶ Here's a simple one-point perspective marker sketch for the interior of guitarist Eric Clapton's baby-blue roadster (see Chapter Eight). Once I have the layout of the interior roughed out, I come back in with the marker, starting with light values and working toward darker values. Vignette helps transition out of the sketch. When doing this with marker, try to end with neat marker strokes instead of the scribbled, hacked marker vignettes you see in some crude drawings. That type of marker work detracts from the overall look of your drawings.

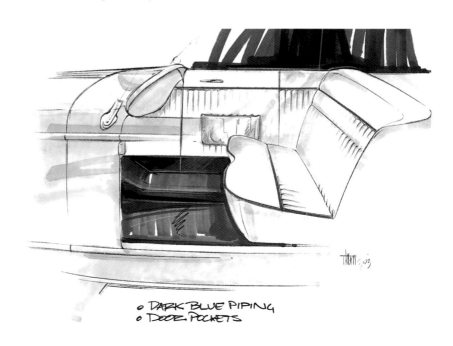

o DARK BLUE PIPING
o DOOR POCKETS

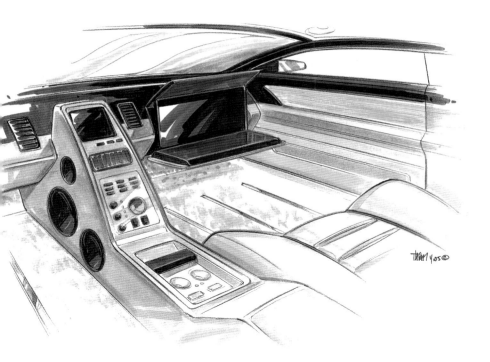

◄ Car interiors are a whole different animal than exteriors. You're dealing with a lot of geometric shapes integrated into the surfaces, and almost no shiny surfaces that reflect or need reflections. Notice how the seat bottom fades away—that's called "vignette" and it's used to indicate something without actually drawing that something into the sketch. I have to vignette a lot of the areas of a car interior or frame them with window moldings, seat edges, or panels. When doing this to show ideas to a client, it's not necessary to show him every square inch of the interior to convey your ideas.

The easy part of an interior sketch is that, for the most part, you will lay it out in one-point perspective. Tipping it up allows a better view and is the preferred choice for the sketch setup. What you decide to leave out can be as interesting as what you leave in. Since one seat mimics the other, it may not be necessary to show both, at least not in a great amount of detail. Also, using a heavy border or other stopping device can keep you from having to render an entire car interior, including pillows and windows—it may give you a graphic element or background off which you can play the interior.

A trick to add interest to your interior sketch is to indicate a texture of a subtle (or wild) cloth pattern. It allows you to add a layer to help define the surfaces further. In addition, it helps to define the perspective when you lessen the detail of your pattern or texture as it moves back into the perspective distance of your sketch.

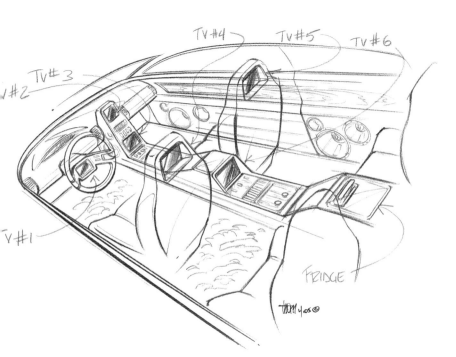

◄ This is a typical interior sketch where a lot of different ideas need to be shown—this being one in a series of sketches. Once the initial ideas are agreed upon, it's time for color renderings like the previous sketch. I'm trying to frame the image with the beltline, or window edges, to contain the interior since it is contained within the car in real life. This was for placement of monitors in a car for rapper Ludacris.

▶ Sometimes, within the same drawing, you'll get to show ideas for both the interior and exterior of a car. Since I wanted the interior to stand out in this sketch, I chose to do it in a color to contrast with the purple—in this case, green. Though reflection is not discussed in this chapter, note how the front tire reflects into the front door— you always have to think of things like this to make the car seem real.

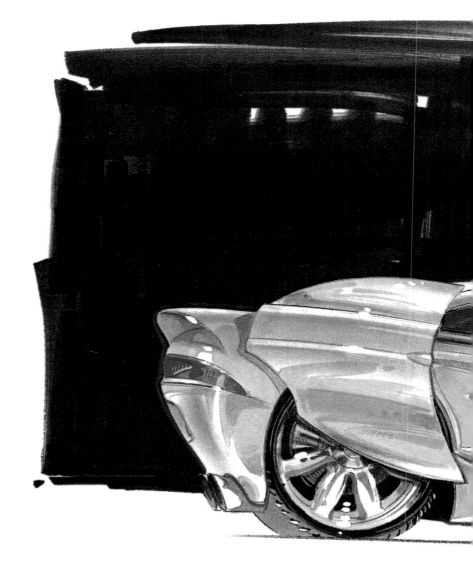

▼ Dan Ellis was an interior designer for Ford for many years, so his examples are definitely from a pro. This sketch started out as a line drawing with the red marker used to block in color. Finally, it was scanned into a computer for the gradations and highlights. Notice that the heavy blue outline helps to separate the interior from the outside, yet it is done in a way that is not heavy-handed. It is also used as a way to tie the details of the steering wheel and seat into the main image.

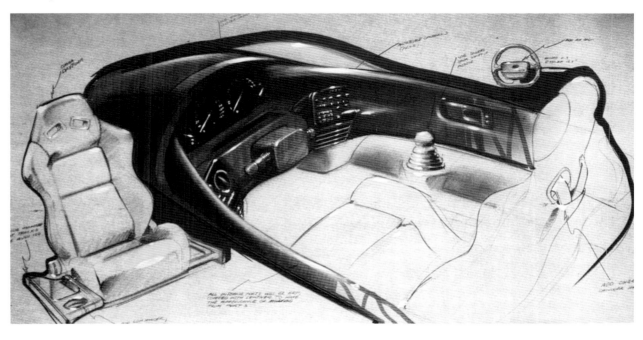

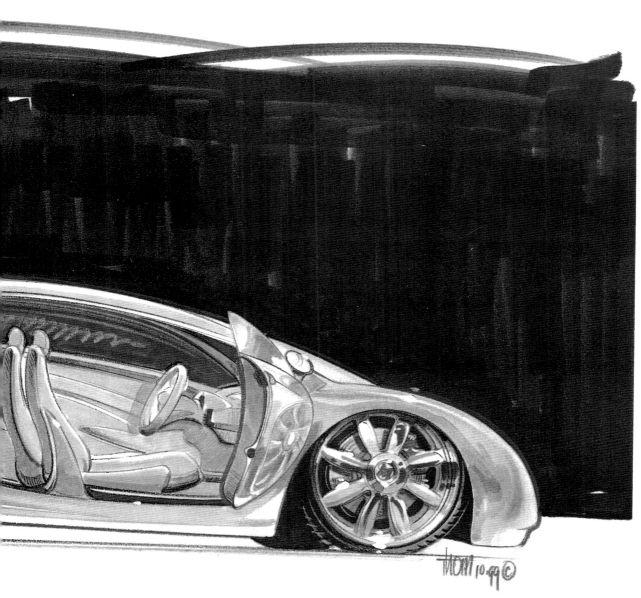

◀ Dan pulled a fast one by sketching this on paper and then scanning it into his computer and reversing the sketch so that the line work appears to have been done with a white pencil on black paper. This adds a dramatic effect and the yellow almost gives the interior a neon effect.

Steve Stanford does all of his art by hand, yet his gradations look like they are done in a computer. Those brown gradations are blown in with an airbrush using animation cell paint. The initial sketch was done in pencil first, and then a bit of black, gray, and brown marker was added. Note that Steve tests different color combos on the right margin of the sketch.

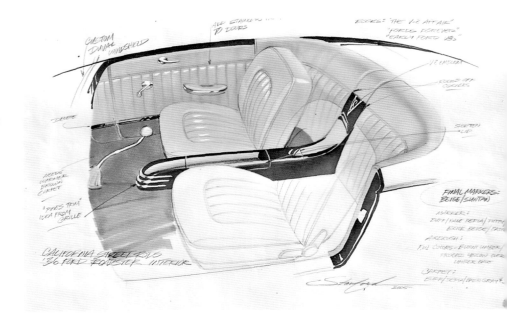

This is an old sketch of Charlie's done in pencil, colored pencil, and marker on marker paper. Recently, he scanned the rendering and detail drawings and assembled them as one presentation, then added the textured background. As usual, Charlie's work is always very precise with no detail left to the viewer's imagination.

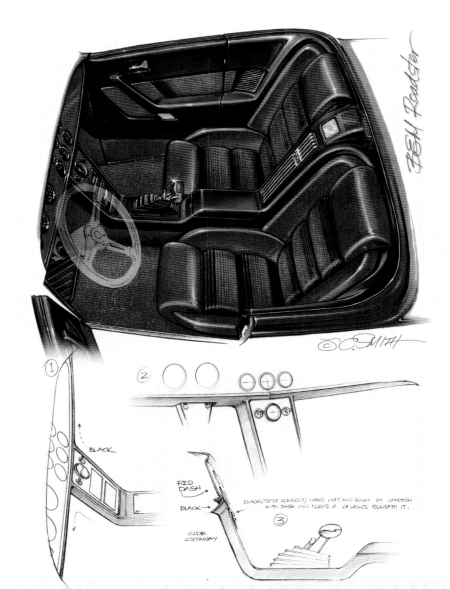

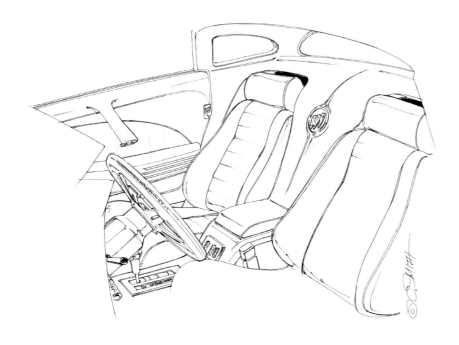

◄ Here's a look at one of Charlie's initial sketches and the final rendered version. Once he nails down the design, he sketches his interior in black ink, scans this drawing, and adds the color in the computer. In some cases, where a line indicates a subtle surface change, he adds a highlight but also eliminates the black line. In many cases, his line work is only a guide to be erased as the sketch progresses.

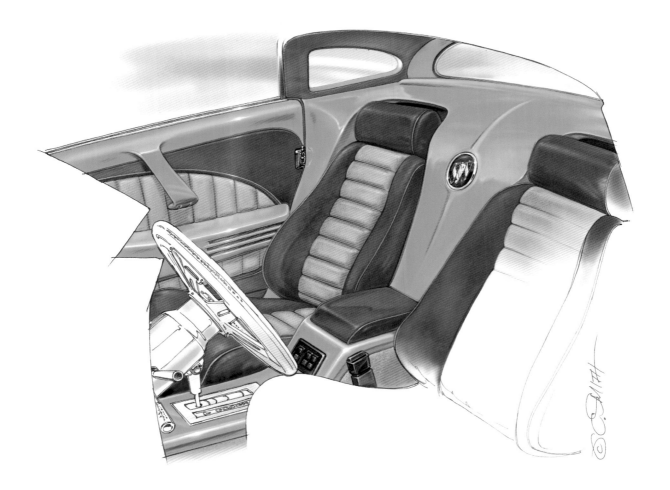

Computers

Let's get one thing clear right off the bat: Computers will not draw cars for you. They are only tools to assist you in drawing a car. A computer may make you better, but only if you have a working knowledge of the previous 14 chapters of this book. I've seen computer drawings of cars, and you can immediately tell who has a solid understanding of the basics of drawing, and who has the understanding of the basics of computer operation. Don't delude yourself into thinking otherwise. Everything your computer will do is only a head start to drawing cars on it. But with this understanding and some imagination, developing a computer sketch can be fun and rewarding.

As a tool, the computer becomes another medium you can use to create. Just as a pencil sketch, pastel rendering, or oil painting gives a unique look to your work, so, too, will a computer. It offers you choices and looks for your illustrations that could never have been achieved with a pencil, brush, or real-world tools.

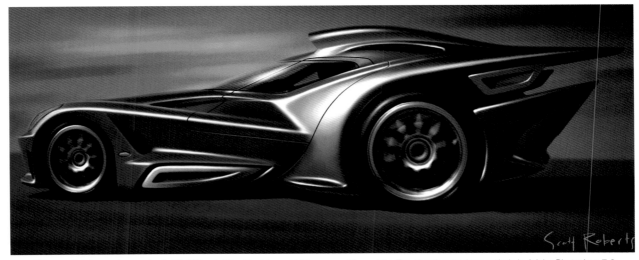

▲ This car sketch was for a potential Hot Wheels idea I had been kicking around for awhile. The sketch was done entirely in Adobe Photoshop 7.0.

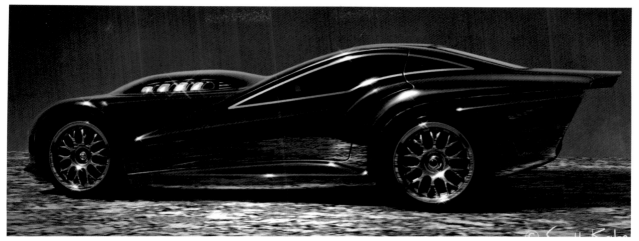

▲ This sketch was also done entirely in Photoshop. As you can see, it is an overly shiny black car done as a warm-up for one of my educational rendering DVDs.

So let's say you know the proper way to draw cars, but you love computers and would like to combine that love with your knowledge of drawing cars. How do you do it? There are three basic ways to do a drawing on a computer. One is by sketching your car on paper and scanning it into the computer. Then you come into the scan and can clean up your lines, manipulate them, or leave them alone and render-in the sketch with color or gray tones. Different finishes can be applied to each component or body surface. Some programs have filters that can apply an airbrush or painted look to your illustration. The finishing touch can be a scanned or drawn background.

The second way is to use a pressure-sensitive digitized pad and stylus. With this equipment, you can sketch your car right on the screen by pressing the stylus on the pressure pad. In this way, you are actually drawing with the computer. Increased pressure from the stylus on the pad increases the line weights or

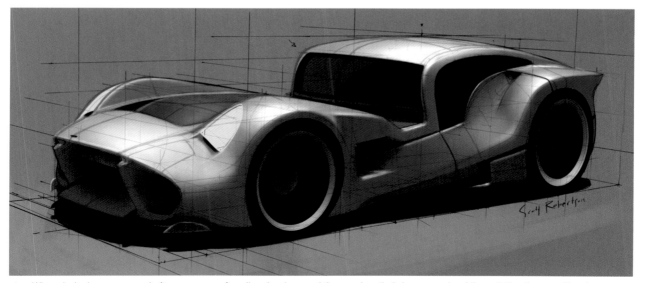

▲ When designing a new car, I often scan one of my line drawings and then work entirely in gray scale while sculpting the car with value changes. Always remember that the human brain interprets form changes through changes in value. Learning early to manipulate these changes in value will give you greater control when trying to illustrate new surfaces that you design from scratch.

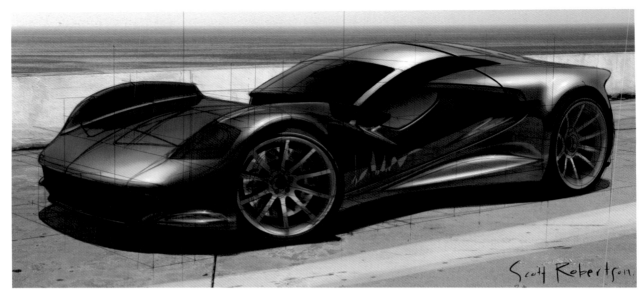

▲ This piece is a work in progress, as you can see by some of the unfinished areas and my line drawing on top. When working with digital tools like Photoshop, it is easy to scan in your line drawing, place it on a layer above all others, and then composite it in such a way as to make everything that is white become transparent. This can be a very helpful technique when trying to render a specific design. When the rendering below is complete, you can then simply turn off the line drawing layer floating above to be left with the photo-real rendering.

emphasis of the line work. As you will see in some of Ed Golden's illustrations, there are other things these stylus and pad components allow an artist to do. Good eye-to-hand coordination is essential here, so all of those computer action games you wasted your time with in your youth may finally come in handy! The sketch is then finished off in the same manner as the scanned pencil sketch in the previous example.

The third way is to scan in a photo and manipulate it, which may or may not result in a photo-realistic depiction, but only if you understand the basics of drawing. It can be very rudimentary at best, unless you take it further. Again, some of Golden's examples give you an idea of what the computer can do in the hands of someone who chooses to explore this method of illustration. You can

▶ Charlie Smith sort of dropped out of the art scene for a while, but he wasn't sitting around drinking Sprite and watching *Oprah*. He was busy learning the finer points of the Mac computer, in general, and the Painter program, in particular. This '39 Mercury was done pre-computer by Charlie, but he later scanned it and refined almost the entire sketch. Highlights, gradations, and details were all changed around to create a much richer, more polished rendering.

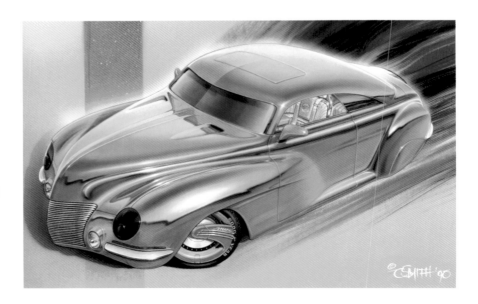

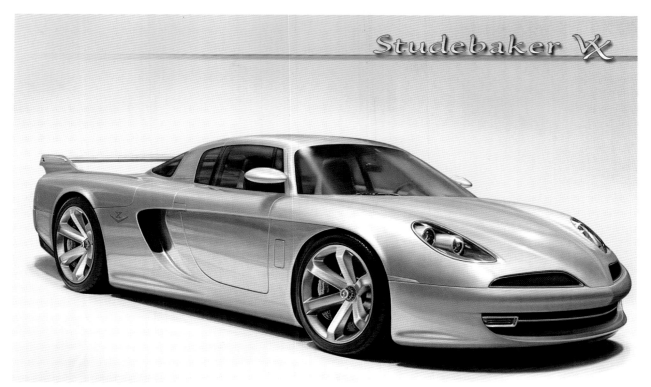

▲ This is the latest form of Charlie Smith art, fully rendered in Painter on his hot rod Mac. This one has all of the hallmarks of a CS rendering—crisp details, nice reflections, and a softness that makes you want to touch the sketch. Note the warm tones dusted into the top surfaces and the cool tones bounced into the sides—just the opposite of what you have been told elsewhere in this book, but it works.

have fun with the photo manipulation, but when you get serious it is best to understand how to draw to achieve some really great art from your computer.

The software scene is changing all of the time, but some things always stay the same. Macintosh is the gorilla of the computer graphics trade, and there are several versions of Photoshop, Freehand, and Painter programs that can do almost anything you need. A lot of these programs are PC compatible, with the distinction between the two systems becoming less and less defined. There are certainly more programs, but these will definitely get you just about everywhere you want to go.

Those using computers for their business or day-to-day dealings will likely be using a PC for most of their work, but there are larger programs for specialized computers that professionals like automobile designers use. These go beyond merely creating drawings—they can render forms in 3-D. The rendered shape can be animated to look like it is moving, while allowing the viewer to see the car from different perspectives in one, fluid movement. Once the sketch is approved, the data can be transmitted to either a three-dimensional modeling system such as stereo lithography. The information can also be fed into a CAD/CAM for engineering and tooling. These are the real benefits to computer-drawn images. Plus, this gives the designers more information and flexibility, while allowing them to see their work in a whole new environment.

There are so many programs for drawing cars, and within those programs so many different procedures to accomplish the same action that it would be impossible to give any kind of reasonable step-by-step examples in this chapter. Instead, we'll show you a number of really great artists that also happen to be proficient in the subject of computer-drawn cars to give you an idea of just how versatile the

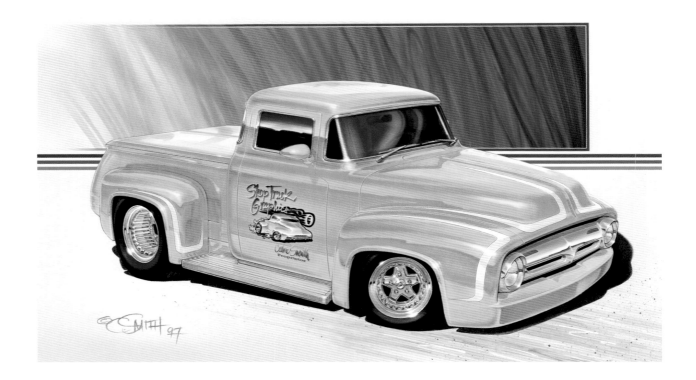

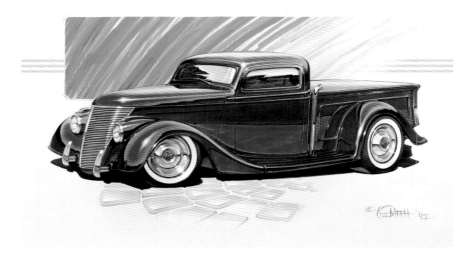

▶ These two truck renderings are sort of the in-between phase of Charlie's art—they're partially rendered with marker and colored pencil and then scanned into the computer to sweeten up the gradations and highlights and generally liven up the colors. The rich yellow of the '56 and deep red in the '35 are hard to get with markers and chalk—but with the computer you can punch up the colors or change them all together if you don't like them. These images and many more are available as prints on Charlie's Web site, www.motorburg.com.

computers and programs are. Also, you'll see how varied the sketches can become when the artist slinging the pixels really understands drawing.

The bottom line is this: The computer is a dumb tool. Over-reliance on it will kill any creativity, spontaneity, and variety you may have hiding within that gray stuff between your ears. Unfortunately, I see this way too often—just look at some of the new cars coming out of Detroit! My hope is that you'll be inspired to learn to draw and then expand your abilities by plugging in a computer and taking it for a spin. With your knowledge of car drawing and your abilities and imagination enhanced with the capabilities of the computer, you should be ready for just about any assignment that flies your way.

▲ With the points and paths method of creating art, such as with Macromedia Freehand, you create the areas you plan on pouring color into. You want to be able to control the blends and gradations with these solid chunks of color. Computer wiz Jim Bruni has provided a couple of preliminary examples of a Formula 1 car. Once these areas are fused, they create a seamless gradation or blend.

▲ Color is overlaid into the paths for you to see how the blends are created. Some of the red guidelines will be turned into black lines, while others will be eliminated.

▲ The final version of *Loose Canon* without the paths. The actual coloring takes a fraction of the construction time, so there is much delayed gratification. It's a different way to create a piece of art, but with practice and the fundamentals of illustration firmly adhered to, the results can be like Jim's.

▶ Jim Bruni mainly uses the Macromedia Freehand program for his illustrations. Here he has dabbled with Photoshop to give us an example of a piece of art that uses filters with very non-default settings. Instead, he has explored beyond the defaults to achieve the effect of an impressionistic charcoal/watercolor image on toothy paper. Does it look like a computer created it? Does it look like other computer-generated art you have seen? Use the computer as a tool to create what you want, not what the default setting limits you to doing.

▲ This is another great piece by Jim Bruni showing how he uses the Macromedia program and lots of blends to create this voluptuous 1957 Lister Jag. The shapes, blends, and colors are simple and refined, just like the car, which is a testament to Jim's restraint. One problem some artists have is when to stop.

▲ Ed Golden likes all kinds of racing. Though an accomplished artist and automobile designer, he often rifles through his collection of photos until he finds one to manipulate. Many of these images are available on his www.speedimages.com Web site. Ed likes to veil the photos and then pull out the areas he wants to detail. With different filters, he's able to give the illusion of speed but also of a painted image, thus obscuring the art's photographic origins.

◀ Changing day to night and a static photo to pounding acceleration—that's what Ed's illustrations are all about. I've been with him at vintage drag racing events, and believe me, this race car was sitting under a tree in a parking lot on a Sunday afternoon. When you like to mess around with cars and art, anything is possible.

▲ Though a lot of Lance Sorchik's cartoons appear in Chapter Twelve, I thought I would include one here to bring up the point that your computer art doesn't need to be involved and tricky to be good. Lance uses his great rough sketches to get the basic image down and then inks it in before scanning it into his Mac. From there, it's just dumping color into the spaces and coming back with the airbrush tool or Wacom pad and stylus to gradate the basic surfaces and highlight the car for maximum effect with minimal complexity. The final product is waaaaaay cool!

As mentioned, Darrell Mayabb does all of his drawing on a computer in Adobe Photoshop. He has lots of examples of his work on his Web site, www.automotivegraffiti.com. In many cases, he avoids complex reflections and instead uses gradations with highlights to make the car's painted surfaces read as shiny. His years of painting and illustration work have allowed him to spring ahead and create colorful, punchy, and crisp illustrations with his computer. It's a new tool that he has added to his already formidable arsenal of art and illustration knowledge.

◀ Ed Newton has embraced the computer wholeheartedly. He still sketches the cars in pencil before scanning them in and adding color and effects on the computer. In some cases he converts portions of his scans into layers, manipulating them before converging them to create a whole different look than what he started with. In the case of the side view of the Cosmic GT, he was able to add the cool background right from the computer.

Greg Tedder is one of the preeminent shirt designers in the country. His style is a little different because he has to concern himself with layering different colors for each of the limited amount of silkscreens available for each design. He tries to stay away from gradations, too, instead layering in solid chunks of color. When combined, they give the effect of a rich gradation that is very hard to achieve with a silkscreen on a T-shirt. They come out on the shirts punchy and rich, and pop right off of the chest of whomever is wearing them.

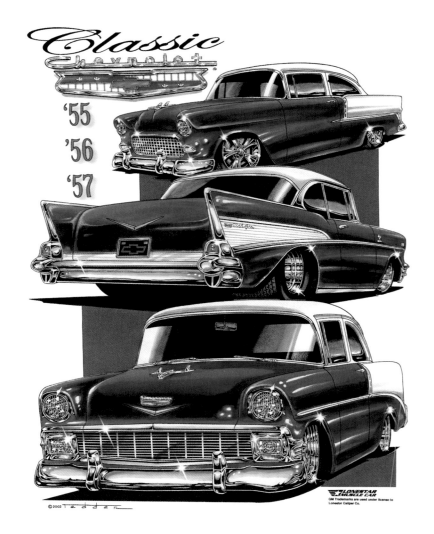

Dave Deal has been represented throughout this book for all kinds of great art and techniques. He's included here for his simple use of the Mac to enhance his already cool cartoons. The two examples shown are two different approaches to Adobe Photoshop. In the Ford Focus cartoon, he inked a drawing and colored it in the computer. With the Ferrari, he took an older pencil drawing, scanned it, and colored it right over the pencil strokes. For chrome indication, there is the simple sky blue on top surfaces; a brown tone indicates the ground bouncing up into the lower chrome surfaces. For painted surfaces, simple gradations with highlights finish off these lively cartoons. You can view a lot more of Dave's work at www.bigdealart.com.

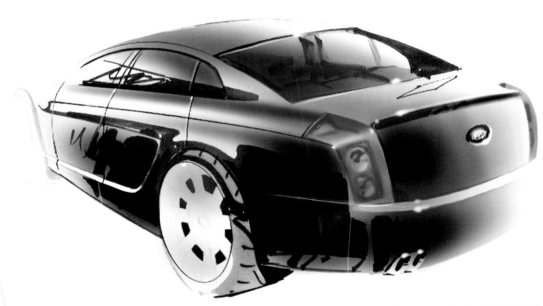

ot of design studios today want a variety of clean, quick sketches representing several ideas they can review in a short amount of time. This is sketch is an example. Once the perspective is determined and the design elements are hammered in, simple black marker is the next there, the sketch is scanned and colored in right over the existing scan. The dusted-in color and highlights quickly allow the studios to e surfaces and design details. Danny's marker gradations are bold to the point of being crude, but with the color dusted over them they nd read well as reflections. It's simple and direct, and acts as the perfect tool for major design decisions.

Schools

If you are truly interested in drawing cars or products—I mean really consumed by it—or have always wanted to dream up cool spaceships or creatures for movies, and you have sustained that interest in spite of this book, then a next possible step is to look into enrolling in a professional school that caters to automotive or product design.

Think about it: Every product, from a TV zapper to a semi truck, needs to be designed. That means it needs to be drawn. There are schools that teach this process and lay a strong career foundation. In the United States, there are two colleges that have a great reputation for this type of education. Art Center College of Design in Pasadena, California, and College for Creative Studies (CCS) in Detroit, Michigan, are famous for their graduates making up the bulk of design staffs in the automotive, consumer product, and toy designing fields.

Both Art Center College and CCS are accredited four-year colleges that provide the necessary skills and training to forge a career in automotive and product design or design for the movie industry. They utilize working professionals who take time to teach, so you are instructed by those who are in the field of design and who probably have degrees from the very school at which they teach. All aspects of design are covered, with an emphasis on conceptual drawing and visualization. I am a graduate of Art Center and have taught there, too, so I'm a firm believer in going this direction if you are really serious about doing this type of work. The big restriction will be cost—these schools aren't cheap! Grants at the high-school level are one avenue to pursue, and student loans have become almost mandatory for the costs involved.

Additionally, there are state colleges that have automotive or product design classes: Cleveland Institute of Art in Ohio and Wayne State in Detroit, Michigan. Obviously, you should do the research on all the schools you have an interest in attending. Keep in mind that some colleges continue to get into the process of design, without getting into the actual conceptualization of a product or car. That's OK, but ask to see completed projects and models. If they hand you a notebook of diagrams, research, and a few pictures, look elsewhere. The research and marketing of a product are very important parts of the design process, but you want to draw and design, right?

If you are in high school and think this field is where you want to be, Art Center offers Saturday classes for high-school-level students. This can be a terrific way to get professional training early on, and it also gives you a chance to work in the school's unique environment. It may initially be intimidating but can quickly become intoxicating, what with all the other projects and activities going on at the school. It gives you insight to the comings and goings of the students, and exposes you to lots of excellent student work. Unfortunately, this only works for Southern Californians or those who choose to relocate there, since the school is in Pasadena.

Regardless of the level of your education, if you're still in school, it would be a good idea to take as many art classes as possible. Tell the instructor your particular interest is drawing or designing cars, and ask if you can get some help and be allowed to pursue that goal. Most teachers are eager to help when a student has a specific objective and shows initiative.

The addresses for these two institutions:

Art Center College of Design
1700 Lida St.
Pasadena, CA 91103-1999
www.artcenter.edu

College for Creative Studies
245 E. Kirby
Detroit, MI 48202
www.ccscad.edu

Since its inception, the automobile has been an object of promise, adventure, freedom, beauty, lust, and mystery. Almost everybody owns one. Almost everybody wants one. And it's up to a new generation of designers and illustrators to carry the torch that was ignited by many brilliant and creative talents during the twentieth century.

Your job is to put the twenty-first century into a car that will perpetuate the American Dream—one that looks good, feels good, and performs better than its forefathers. Good luck.

Appendix

Contributing Designers
Dave Bell
1834 Asbury St. N.
Falcon Heights, MN 55113

John Bell
www.johnbellstudio.com

Jim Bruni
401 Le Droit Ln.
Laguna Beach, CA 92651

Dave "Big" Deal
www.bigdealart.com
www.bigdealtees.com
www.koolart-usa.com

Dan Ellis
formdesign@earthlink.net

Ed Golden
www.speedimages.com

Darrell Mayabb
www.automotivegraffiti.com

Ed Newton
PO Box 1034
Dublin, OH 43017
newtinator@gmail.com
www.newtzart.com

Scott Robertson
scottr66@aol.com

Charlie Smith
www.motorburg.com

Lance Sorchik
PO Box 7258
Sussex, NJ 07461

Thom Taylor
hotrodthom@cox.net

Greg Tedder
www.tedderdesigns.com

Index

**How to Draw
Choppers Like a Pro**
ISBN 0-7603-2260-0

**How to Draw Cars the
Hot Wheels Way**
ISBN 0-7603-1480-2

**How to Draw
Aircraft Like A Pro**
ISBN: 0-7603-0960-4

How to Design Cars Like a Pro
ISBN 0-7603-1641-4

How to Photograph Cars
ISBN 0-7603-1243-5

**Hot Rod:
The Photography of
Peter Vincent**
ISBN 0-7603-1576-0

**Billy F Gibbons:
Rock + Roll Gearhead**
ISBN 0-7603-2269-4

**Hot Rod:
An American Original**
ISBN 0-7603-0956-6

**The Cars of The Fast
and the Furious**
ISBN 0-7603-1551-5